Jasper Johns

MODERN ARTISTS

Max Kozloff

Jasper Johns

HARRY N. ABRAMS, INC., PUBLISHERS, NEW YORK

Standard Book Number: 8109–4423–5
Library of Congress Catalogue Card
Number: 74–175943
Printed and bound in Japan

Contents

List of Plates

*Colorplates are marked with an asterisk**

Jasper Johns

MODERN ARTISTS

JASPER JOHNS MOST VIVIDLY AND IMPORTANTLY AFFIRMED HIS PRESENCE IN AMERICAN ART by virtue of his scepticism. He cast doubt on the allusive functions of paint on canvas and volume in sculpture. It was a natural consequence that his works in these mediums—often enough he was even indifferent to the traditional distinctions between them—suggest no more space than is actually there. Consistently what had been symbol in art he remakes into sign, and what wanted to be the illusion of depth, he insists on calling flat. One thinks of him as an artist who dislikes and discredits metaphor because metaphor is imprecise. To him it calls for excessively arbitrary habits of belief. Johns's precision consists in being less credulous than his viewers. His literalism may oppose him to the physically unclear, yet it also commits him to the conceptually indefinite. He cannot analyze any set of terms in his work without immediately foreseeing the validity of reversing their meaning—and of keeping that reversal open. He structures his art so as to give to its every contradiction an equal weight. This is the logical character of his thought. But it is a logic that comes to have an expressive, and eventually a poetic, value that is passed on through themes of paralysis, self-estrangement, and the interferences of memory.

New York art of the fifties, when Johns first appeared on the scene, was given over to ambiguous procedure, a subject upon which contemporary criticism was fixated. For example, the artists devoted to confusing figure and ground, or deep and shallow space, were legion. Continuing problems on another and related level involved the tendency of representation to increase its threshold within a never entirely pure abstract art, and of "found" objects to wander into sculp-

ture. Larry Rivers adapted the wide, loaded brush gestures of Action Painting (along with a mincing, sketchy drawing) to a repertoire of subjects ranging from a crib of Leutze's *Washington Crossing the Delaware*, familiar in every schoolroom of the previous twenty years, to a double portrait of his naked mother-in-law. Richard Stankiewicz assembled rusted boilers and plumbing into flagrant sarcasms about urban life. Such artists prominently introduced derisive or grotesque accents into the subject matter of fifties' art. Their tactics depended on making their ends and means variously insolent in the ways in which they related to each other.

Even the chief admirer of Willem de Kooning, Al Leslie, could not stay altogether in the wake of the master's agonistic style. While some of the marks made on canvas during the late fifties were claimed to be the outcome of struggle, risk, and uncertainty, they often *looked* quite euphoric. Replete with marvelous lacy drips and carbonated spatters, one of Leslie's pictures was called *Arrivato Zampano*, in reference, amusingly enough, to the brutish, pathetic strong man (played by Anthony Quinn) of Fellini's *La Strada*. As for Robert Rauschenberg, he exhibited, with diffident bravado, an erased De Kooning (drawing) by Robert Rauschenberg. No act could have been more symptomatic of the youthful revolt against the humanism of the first generation Abstract Expressionists. Students of the New York School were slipping out of tether.

Jasper Johns had not really gone to class with them. Born in Georgia in 1930, he worked in obscurity and under no outside influence until 1958–59. Where most idioms around that time were very painterly, light-footed, nuanced, and uneven in density, Johns's first mature paintings—the notorious targets and flags of 1954–55—were closed and regular in layout, relatively pure in color, and systematically thick in paint build-up. In context, the art of this twenty-five-year-old appeared archaically rigid. Even though disjunctive, as when he compartmented colored plaster casts of body parts over a target image, his choices seemed to emerge out of a calculated, if baffling, program. At no time could he be construed to have worked in a spirit of improvisation or expediency. During the era of the Beats, of the ascendancy of Zen, and of method acting, with its graphic gutteralism, Johns's planning appeared radically alien as an artistic enterprise. But through the sheer force of its absurdity, it was impossible to overlook or forget.

This absurdity operated in many areas. With his tabular alphabet or number series, the artist purveyed motifs completely "unworthy" of the caressing attention, the gradated decorum he lavished upon them. It was as if each impersonal, stenciled sign became a *personage* despite itself. Yet this tender brushing was so equable and impassive in overall

texture that it did not seem so much the invocation of a mood as it was the record of an attitude. Moreover, Johns's subjects as well as his whole approach to subject concentrate on man-made still life, while his handling is more attuned to the depiction of organic landscape, for example, foliage. Here was an artist who concerned himself only with objects or flat emblems and yet consistently cancelled out the way they are perceived. Landscape is usually experienced at a distance greater than is the case with still life; yet the space of Johns's painting up to 1959 is homogeneously up front. Then, too, he could not be considered as either a representational or an abstract artist. Being itself a prime image, a number or a map could no more be "depicted" than a painting whose icon is a number could be judged nonfigurative. The eminent neatness and efficiency with which the artist de-categorized the perception of his work seemed at the time profoundly irrational. There was about it an uncompromising perversity, a ridiculous pragmatism.

Psychologically, Johns might be said to have put visual art into a bind. With their built-in latitude of approach, the action painters could encourage varied, ad hoc interpretations of a formal ensemble. The unity of their field accommodated and depended upon the spectator's unpredictable choices of meaning. But Johns forces us to read his art on an "either-or" basis. He edges us off into a predicament whereby the plausibility of any one statement is destroyed by its antithesis—a new species of unity.

In Joseph Heller's *Catch-22*, perhaps the most celebrated American novel of the sixties (although it was written during the same period as that in which the targets and flags were painted), the bind becomes a central motif (the book deals with World War II bomber flyers):

> There was only one catch and that was Catch-22, which specified that a concern for one's own safety in the face of dangers that were real and immediate was the process of a rational mind. Orr was crazy and could be grounded. All he had to do was ask; and as soon as he did, he would no longer be crazy and would have to fly more missions. Orr would be crazy to fly more missions and sane if he didn't, but if he was sane he had to fly them.[1]

And Heller goes on to comment that "There was an elliptical precision about its [this bind's] perfect pairs of parts that was graceful and shocking, *like good modern art.*" (italics mine). We do not know what art Heller had in mind. Yet for all

their differences, he has in common with Johns an image of human will hobbled by lucidity because it is based on the learning that experience itself makes no sense. And this image is expressed in the repeated schemata and manic conundrums that constantly circle through the work of the two men.

For most artists, the emotional environment of the fifties had been more upbeat. Remembering, Morton Feldman writes: "What was great about the fifties is that for one brief moment—maybe, say, six weeks—nobody understood art."[2] If so, Johns was the exception whose rigorous understanding provided nothing so trivial as assurance. The belief system of Cedar Bar painting relied on the myth of one inspired, life-giving instant of confusion—"crisis" was the term the critics approvingly gave it. Johns profaned that myth by showing that certainty only offered more vantages on enigma. But it was an enigma that emerged from the give-and-take of the viewer's engagement with a physical object, and not in how he could be made to empathize with an artist's version of *his* dilemmas. Among the Abstract Expressionists, the element of doubt mingled with a declaration of hope. Not knowing how to proceed induced a new procedure; not being able to determine finish implied a new completion. The artist's awareness of disability brought him closer to a possible transcendence of self. This constituted the dramatic and moral underpinning of the Abstract-Expressionist movement. There is very little of such *angst* in Johns, and nothing of its eventual pride. To him, on the contrary, *all* theories of artistic creation and formal necessity are problematic. But this in turn neutralizes the very notion of problems, since, our ultimate condition being one of impasse, one enlightenment is as good as another. Wittgenstein said: "The solution of the problem of life is seen in the vanishing of the problem."[3] But Marcel Duchamp, Johns's real mentor, wrote: "There is no solution because there is no problem."[4]

What kind of sense did such a weirdly determinist position make in the sixties? If Duchamp was to exert his greatest influence in that period, the creator of the targets became his medium. Certainly Johns appears as the prototype of the cool, detached artist of the decade—ironic, business-like, productive of cunning distinctions. Though knowledgeable about art history, he declines to burden himself with the obligation to remake it. Though not necessarily sociable, he involves himself deeply with the responses of the spectator—indeed, predicates much of his work on manipulating those responses.

Even if they wanted to, however, sixties' artists would have been hard put to mime his nice internal balances. Rather, his "perfect pairs of parts" were so finely poised as to be of an incalculable suggestibility. Jim Dine and Claes

Oldenburg, for instance, saw the possibility of animating them with a kind of comedic alarm. Their shiny art burlesqued Johns's refinement yet upheld his displacements. As for the work of Andy Warhol, it is hard to imagine it existing without the precedent set by Johns in his serial and mechanistic arrangements of units, although Warhol infused these with a decadent glamour.

Just as meaningful as its lesson for Pop Art, the physicality of Johns's vision had great authority for abstract sculpture. Robert Morris wrote:

> Jasper Johns established a new possibility for art ordering. . . . the work was looked at rather than into, and painting had not done this before. Johns took painting further toward a state of non-depiction than anyone else. . . . [he] took the background out of painting and isolated the thing. The background became the wall. What was previously neutral became actual, while what was previously an image became a thing.[5]

Morris owes to this kind of reversal the inspiration for his extremely Johnsian lead bas-reliefs of the early sixties. And from Johns's stubbornly thinglike "art-ordering" derives Morris's, as well as Don Judd's, minimal (or literalist) sculpture of the mid-decade, not to mention Carl André's, Dan Flavin's, and Richard Serra's most important work a bit later. From the example of the flags they understood how a variable relatedness of forms was itself a *metaphor*, as well as a result, of continuous decision in modern art, and also how it would be possible to liquidate that metaphor by making all relationships either equal or progressive in a set rule. Even non-geometrically-oriented art, like jumbles or heaps of heterogeneous materials—felt, hay, chicken wire, etc.—could be subjected to this same kind of depersonalized outlook. Complex, amorphous compositions were to be seen just as much as "given," just as much ordinary fixtures of the environment as the most everyday digits. Throughout, one was dissuaded from considering one path of observed connection between forms more purposefully in focus than any other.

The same holds true of the first five crucial years in the development of Frank Stella. Of Johns's initial one-man show in 1958, Stella said, "The thing that struck me most was the way he stuck to the motif . . . the idea of stripes—the rhythm and interval—the idea of repetition."[6] In Stella's hands, these features immediately eventuated in black and then metallic monochrome fields through which was channeled a structure as much involved with parallelism, symmetry,

duplication and reversal, as was Johns's. Indeed, in 1962–63, Stella painted a diptych, *Jasper's Dilemma*, whose concentric square mazes—the one in multiple colors, the other in various grays, whites, and blacks—seem like a dissection of Johns's strategies. Stella was to become an artist, like Johns, fascinated by inverse reflections and twin patterns expressed by the flanked segments of a composition. Here he was largely to follow the example of the older artist whose flop-over or "folding" of shapes produces horizontally and/or vertically symmetrical wholes.

A major tendency of sixties' abstract painting was to display itself in permuted sets whose structure stays the same, but whose palette changes. That way of imagining things stems, through Stella, from Johns. With more pronounced coloristic freedom and broadness, Kenneth Noland articulated the mode in his "target" and his succeeding chevron paintings. Finally, the small color discs on the surfaces of Larry Poons's paintings were sprinkled according to a mathematical ratio, so diminishing and expanding as they turned around penciled rectangles, that one quite lost or ceased to care about the order implicit in what appeared to be randomly marked fields.

Needless to say, more was broached in the evolution of these various systems of composing than the requirement of strict control or neutral aggregation. Sixties' artists desired an affective result that distanced and often deadened the spectator's powers of empathy. This aim was embodied by a mulish, inertial presence that stood in contrast to persistent switches of style and multiplications of data. Without any classicizing ideal of stability or harmony, artists of the period devoted themselves to enormously commanding and obsessive images incapable of being developed because their repetitive syntax lacked any consistent principle of growth. Everything depended on the invention of new systems and the deployment of new materials (acrylics, vinyl, Fiberglas, etc.), whose conceptual and sensory qualities could be exploited. As this art took hold of the public imagination, it gained an unmistakable affluence and an appetite for gigantic scale. Under these circumstances, an enthusiastic theme, such as Warhol's *Marilyn*, came to *feel* especially ironic; while a monotonous grouping of totally abstract cubes—one thinks of Donald Judd's wall modules—seemed almost *illustrational* in its sterility.

These, of course, were precisely the attributes unfavorably imputed to Johns by some of his earliest critics. And it is true that he, if any single artist, can be regarded as instigator of the ironic genius of American art in the 1960s. But how much more muted and devious he is than his successors of such high caliber; how much more, especially in direct competition with them, does he insist on his stake in the sensuous consciousness of the fifties. For it was natural then

that artists might say of their work, as Johns says even now, that it "is about the move of a hand from one point in space to another nearby."[7] Johns does not mention, however, that that movement was for a long time patient yet restless, as if droning on in an unknown script.

Let us acknowledge from the beginning that Johns's fundamental impulse is to conserve energy and to remember what is on the surface—to hold on to the material appropriated. For he rarely invents, and as much as possible he avoids the unfamiliar. Rather, the dynamics of his career have to do with the constant alteration of the pictorial and sculptural surroundings of long-lived and loyally retained motifs. He wants to standardize and reduce the number of flattened images, which his touch gentles. It is not enough that his objects have an almost archetypal status to begin with. He sees to it that they crop up again and again in his development to create a deliberately *déjà vu* effect. After 1964 he seems to begrudge himself the introduction of any new subject, or at least subject cycle, and to concentrate, this time almost exclusively in the medium of prints, on the business of memorializing his past output. As the *Green Box*, that miniaturized compendium of all his earlier art, was to Duchamp, the Gemini graphic workshop has been to Johns. His is an art continually glancing backward, yet far more fearing to look nostalgic than redundant. For his goal is not manifested through any personal fondness for a map of the United States, targets, device circles, handprints, numbers or the names of colors, but out of an insatiable longing to *complete* the possible gamut of nuances and arrangements with which any of these may be presented. That is the realm to which his spontaneity has receded, and where he alone feels comfortable.

As a result, with any two of his works having the same theme, the image is aesthetically unique yet, for practical purposes, structurally indistinguishable from its mate. Johns has a pendant psychology that takes pleasure in pairing off twin icons for the purpose of reaffirming not merely the vicissitudes of his handiwork, but also the fact that there is a positive and a negative aspect of any object or field. His *False Start* and *Jubilee*—the first canvas in color, the second in various blacks and whites—have roughly that relationship to each other. And in a single composition, *Painted Bronze*, one simulated Ballantine Ale can is hollow where the other is frightfully heavy and solid. One could also compare the bronze cast flag of 1960 with a Sculpmetal and collage flag on canvas of the same year, to see how near-twins can diverge from each other in tactile emphases, surface hardness, warmth of tones, and the like.

Such is an elementary, polar contrast between separate, single images having the same social and configurational identity. The fact that one cast is used to produce two subtly different objects provokes thoughts about genetic comparisons, alter egos, proxies, and preceding and succeeding "runs" of a subject. Generally, it may be imagined that one version is a prototype or pilot, the others, variations. But the artist shows us that such distinctions are futile: what price the difference between wax or metal, empty or full, color or grisaille, open or shut (the wooden compartments of *Target with Plaster Casts*), and finally, front and back (*Canvas*)?

When Johns includes several images on the canvas, he differentiates them with greater homogeneity. Here simple, dumb progression takes over: the stenciled *0 Through 9* paintings and prints and the alphabet paintings, where the row of letters commences, comes to its end and starts over again. So, too, the artist writes in a sketchbook note, "Take a canvas. Put a mark on it. Put another mark on it . . . (Ditto)."[8] Dualistic in his pendant works, Johns becomes mechanistic in his numerologies, for he is able to think of the very way he executes as merely a sequence of equal steps: none more analytic or expressive than any other; all peers of each other because they have in common the obvious fact that they are no more than physical additions. The painterly irregularities and pressure changes observable as the eye moves along any axis in these paintings are very consistent, choppy, calligraphic, miming or confusing the figure edges, and, overall, quite beautiful. They are also, within their little frames, one of a kind, non-repeating, a seemingly incessant spread of nondescript variables.

Such programming might not have held any more interest than a time-motion breakdown of any circumstantial activity. What ramifies Johns's method is his exquisite awareness of the limitations of visual art in storing memory traces of the world. These limitations very properly have to do with available space. A canvas is one physical thing; only so many marks can be deposited upon it before it is "filled up." Moreover, painting or modeling is a "covering-over" activity. (It is no more than common sense to admit this, and Johns is eminently sensible.) Later applications of paint carpet the earlier ones, which tend to vanish from sight. Now if we bear in mind that Johns is a particularly conservationist- and literalist-artist, we might see how he would feel victimized by the intransigent economy of visual art and by the knowledge that the very process of creating is entangled in the operation of subtracting. And all the more painful would be his awareness of this bind because illusionism, the metaphorical device for hollowing out space, has been ruled out of his aesthetic. Everything that happens within the perimeters of a Johns canvas is forced to be "of" the surface,

never "behind" it. In prohibiting depth illusion, and in dealing only with designs or cutouts, he restricts himself to present images on a field that logically have to be traversed in consecutive order. So, his characteristic grids and allover fields would be the archetypal means of employing every square inch of two-dimensional space. One feels obliged to look at such paintings as if one were reading them, in linear fashion.

In accord with this viewpoint, an early Johns "painting"—or is it a sculpture?—is called *Book*, and is precisely the object itself covered with red encaustic. Through the translucent wax filter one distinguishes, without being able to decipher, the typography of two open pages. If the pun is excusable, the work is all "booked up" with thought. So frequent are the appearances of this internal storage of material in Johns's career that his art could be said to lead a double, or rather even a triple, life: the icon (when it appears), the caressing attachment of its brushwork, and the collage scraps of newsprint or stenciled messages embedded everywhere and glimmering vaguely through the permeable wax. Many of the flags, targets, and device paintings are wordy in this respect, abuzz with subliminal dialogue. When the facade bleaches, as in *White Flag*, the effect is of a flag fossil that has been imprinted on a once pliant flesh alive with reading matter!

Nowhere around him, or even in previous art, had there been a precedent for Johns's vivification of paint, his vision of it as a sentient substance layered with the fauna of emblems, signs, and words. For the Abstract Expressionists, viscous, adhesive oil had been the virtual medium for the registration of every large and last nervous gesture or tremor of the hand. The more it seemed to articulate this impression, the more this paint gained a metaphorical strength. But Johns's encaustic is like an actual culture congenial to the growth of "information." It is a nutrient breeding ground for "something else" whose patterns are fathomed within a literally shallow depth. Moreover, wax, like the plaster which Johns frequently used for his sculpture, takes an impression and is suitable for casting. Both substances become malleable either by the receiving or giving off of heat, which departs only to leave a new, solid state of matter. There is a wax painting by Johns called *Water Freezes*, vertically bisected by a thermometer that seems to recall these thermal changes of the medium and to stand witness, like a watchful sentinel, for any dip in heat. Action Painting refers back to an emotional warmth of the artist and symbolizes it by volatile handling; Johns's surfaces, up to 1959, appear to be creating themselves without him; they conjure an organic warmth of their own.

Such an approach, however, is as empirical as it is poetic. For it would seem to offer a solution to the problem of

the limitations of consecutive imagery. By impacting his pictorial substance with signs, Johns can stack his subjects as well as juxtapose them. All that is required is an extreme equivocating tact m the distribution and edging of strokes so that representative episodes from every stage in the temporal history of the painting may bulk in its final tissue.

Suppose, now, that the artist wished to eliminate this nervous elaboration of touch, the Cézannesque discontinuities of which were too pervasive and studied to *narrate* the way any work is realized. One outcome is suggested by *0 Through 9*, where the subjects themselves, the ten numerals, are laminated one upon the other in normal arithmetic progression. Scored as they are in the same space, however, their paths simply plow up the paint substance, over-agitating the facade with pigment that does not know where to go.

Clearly this theme was worked out more successfully in Johns's drawings, and especially his prints—not only because prints can economize space without building up bodily on the paper surface, but also because the artist accomplishes all his modifications of imagery in different overlays on the stones or plates *before* printing. The way prints stratify and yet permanently record artistic decisions is exemplified in a virtuoso manner by Johns in his portfolio of lithographs *0–9*, from 1960–63. Customarily, many stones contribute to one print; but it is perhaps a unique occasion in the history of graphics that here ten *different* lithographs were made from one stone. (An example is shown in plate 44.) Johns's scheme was to number each work by a large numeral, which together with a smaller scaled row of the ten figures above, played out subtle variations as the series moved to completion. These prints register the most intimate carry-overs of handling from one number to the next, carry-overs that gradually give way and are finally wiped clean by the increments of later imagery. The set can be said to be about its own history, that is, its subjection to change as *symbolized* by numbers. Ghostly echoes, reluctant to leave, vie with fresh touches or new erasures, progressively, and yet with supreme gratuitousness.

For, taken singly, these images are powerless to illustrate the reminiscent process which is the "argument" of the total suite. Johns had been able to insinuate an increasingly deteriorating "past" into the "present," but only at the cost of segmenting his operations into multiple works. When, on the contrary, he desires to inscribe the various tenses of his activity all at once and as clearly as possible, as in the baroque charcoal drawing *0 Through 9*, 1960, an entirely new obstacle surfaces.

The draftsmanly program of this work—superimposition—is a very rare phenomenon in visual art. In the paleolithic

caves, it invoked hunters' rituals, cohabitations of spirit, or the possession of the creature depicted. In Cubism, it allowed for a kind of X-ray dissection of forms and structures, unmasking an ambiguous internal space without respect for contours. For Johns, such an essay in transparency is an attempt to mark off the temporal course of hand movements, distinctly designated "1," "2," "3," and so on, plotted within one space, yet without the intervention of "body." Thus in this drawing, numbers, while not ceasing to be signs, symbolize stages of time held intact on the page.

But drawing is a spatial, not a temporal, art. By continually reoccupying the same site with ten differing motifs, the artist has clogged his field. All the numerals have been unswervingly delineated, but they have been given no dimension in which to make themselves intelligible. Rauschenberg experimented with a similar phenomenon once in a combine-painting called *Broadcast*. By turning two knobs protruding from its surface, the spectator activates two hidden radios whose programs can be scrambled at will. The cacophonic effect of the Rauschenberg parallels the cacographic effect of the Johns. It is one thing, however, to manipulate and enjoy random noise; it is quite another to search out some orderly device for retrieving information against the natural grain of one's medium. Johns could not, perhaps, have imagined this disturbing work without the metaphorical simultaneities of Cubism. His literalism, though, brings him closer to the prehistoric incantation whose magic purpose was to gain control of fate. Its florid curves make this drawing good to look at; but the chronic transgressions, making it almost impossible to follow any motif, elevate it to the level of a profound cipher.

Voltaire coldly and accurately defined the madman as an individual who either thinks of one thing all the time, or too many things at once. For his part, Johns is an artist haunted by the possible derangment of the mechanisms that uphold our sanity. Throughout his career one finds a conflict between his urge to extend art's capacity for receiving memory traces and its brute resistance to storing them. He evokes a scenario about the logistics of consciousness. For we are more or less vaguely aware that our imperfect recall may protect as well as frustrate us. Jorge Luis Borges has written a story, "Funes the Memorious," about a monster of memory who contradicts the truth "that we all live by leaving behind." This prodigy "had devised a new system of *enumeration*" (italics mine) that had never been written down, "for what he once meditated would not be erased." Borges's Funes tells the narrator, " '*I have more memories in myself alone than all men have had since the world was a world.*'" And again, " '*My dreams are like your vigils.*'" Now for us, dreaming is a healthy process in which uninhibited remembering is checked by instant, if sometimes incomplete, forgetfulness. In an

important sense, each canvas by Johns structurally emulates each night for the dreamer. Far from emerging with a relatively clean slate, however, he terminates a loaded painting. While our perceptions, conscious or unconscious, do not take up space, the matter in which we allude to them does, and Johns, as a result, seems destined to perform the same litany of actions, multiplying them over and over again in related but separate works.

But the special density of his surfaces suggests a way out of this endless reiteration. If we say that the mind theoretically has an infinite capacity to remember, our mnenomic problem is to screen automatically unneeded data and to extract on demand that which is of use. Freud proposes a model to help us understand our solution to this problem in a brilliant essay entitled "A Note upon the Mystic Writing-Pad." The title refers to a well-known child's game, a tablet upon whose celluloid covering sheet one writes or draws with a smooth stylus. Pressure transferred through the stylus leaves grooves on a wax paper made visible through touching a dark resin or wax pad beneath. One can erase all marks by lifting the sheet away from the pad, thus breaking contact with the coloring agent. At this point Freud explains, "The surface of the Mystic Pad is clear of writing and once more capable of receiving impressions. But it is easy to discover that the permanent trace of what was written is retained upon the wax slab itself and is legible in suitable lights. . . . it [the pad] solves the problem of combining the two functions [of receptivity and permanence] *by dividing them between two separate but interrelated component parts or systems.*"[9] Freud then goes on to compare "the celluloid and waxed paper cover with [our perceptual] system . . . and its protective shield, the wax slab with the unconscious behind them, and the appearance and disappearance of the writing with the flickering-up and passing-away of consciousness in the process of perception."[10] Johns's translucent waxen surfaces, in this respect, appear like mail drops for the subconscious, laden as they are with all kinds of unprocessed messages. Though permanently retained, they are nevertheless barely distinguishable. Freud concludes by saying: "If we imagine one hand writing upon the surface of the Mystic Writing-Pad while another periodically raises its covering-sheet from the wax slab, we shall have a concrete representation of the way in which I tried to picture the functioning of the perceptual apparatus of our mind."[11] In the art of Jasper Johns, the hand descends to leave a stroke that simultaneously reveals and censors. It is his understanding of the manual process as a form of *interference*, invoking that which is remembered while tending to ward off new stimuli, that keeps him from declining too steeply into the one or the other of Voltaire's conditions of madness.

This idea of "interference" has its uses when discussing the artist's work of 1959 to 1964. During this period, he loses his equanimity, if not his balance and puts his "art ordering" under the attack of an almost vicious brushiness. How he opposed the hard-edge style of the sixties, how he came to deal with contradictions between name, image, and knowledge, or the liaison between measurement and chance, I have recounted elsewhere at length.[12] As an index of his emotional outlook, however, the new, agitated handling amounts to a kind of Expressionism. But it is not an Expressionism of achieved release, as in the De Kooning generation, but one of lashing out against a lowering psychic confinement that would hem him in—an abortive imminence that kindles struggle or promotes despair.

False Start, *Fool's House*, and *According to What* are all titles that could have been invented fifteen years earlier but for their self-depreciating tone. As for the content of *Painted Bronze* and *Study for Skin I* (both works kept by the artist in his collection), they go further in being studies of imprisonment. Into that lovingly rendered bronze replica of his Savarin paint can, Johns wedges his brushes, which, so far from being cleansed by turpentine, stew eternally in metal. It is as if matter has taken the bristles into its own, sealed in the "soil" of art without any hope of that lifting away which restores freshness to the remembering mind. Even more extreme is the sightless image of the artist pressing cheeks and hands against the blank caging surface of the paper. Like the sculpture, the drawing appears as a frightful dream that will never relinquish its grip. Doubtless it was intended that the impasse envisioned in these two works brings time to a standstill. Without the potentiality for, or allusion to, change, Johns's art takes on a memorial character. It becomes a relic of triumphant memory, closed to all further experience because paralyzed.

But such moments are generally static exceptions within the output of unstable and even vehement works—replete with many different surfaces and textures—of the first half of the sixties. It can be said of these works that they are involved in breaking contact between the correspondences within our semantic and spatial understanding of the world. This first occurs with a vengeance in *False Start*, where unmixed hues, consecutively disposed in rough analogy to the numerologies, are consistently mislabeled by the stenciled words "blue," "orange," "yellow," etc., which are applied in orange, white, and blue, etc. ("False Expectations [a 'false start']," says Richard Field, "are created by the use of a stencil whose style is inextricably associated with 'contents' [the content of a labeled crate is transferred to the 'content' of a work of art].")[13] Up to this work, Johns was essentially a tonal painter, working wondrously within a range of grays and whites. Now he finds a relation between colors and their names similar to that between the numbers and brush-

strokes—that is to say, a kind of interference. Only this time, interference is far more explicitly mental than it is sensory.

To examine *Fool's House* is to have a comparable experience. Perception and the identity of perception, here concerning the nature of the pictorial space, are pitted against each other. Suspended vertically from a hook, a broom has brushed paint in a pendular motion. But the words at the right, "Fool's Ho . . ." are completed by "use"—that is, what one can do with the broom, towel, and cup—at the left, as if the canvas had been originally mounted on a cylinder. By the subtlest of means, Johns projects a "past" convexity onto the present flat surface.

It is of great interest, finally, that in *Field Painting* one can remove metal objects (a palette knife or a squeegee) from the work and reattach them at will to magnets fixed to wooden letters that spell out the primary colors. Since the objects are among the tools of his trade, and the letters name the colors at work in the painting, Johns externalizes the input that went into his field. It is a field, however, that now actually grasps hold of some of its elements, though not so strongly as to prevent their loss. Unlike all his previous work, its alarming tenacity can be overcome. A paintbrush can be taken off a red "D" and put on an orange "B," so that the viewer himself is encouraged to engage with the separate, divisible, but interrelated conditions of action and result, of perception and memory. It is precisely because works like *Painted Bronze* fuse these terms that they represent the snuffing out of the perceptual apparatus. But the alternative here is ever more panicky as Johns magnifies the quickened cleavages between fact and sign—perversely— down to the levels of separate letters.

The latter are produced in two guises: in three-dimensional form, swiveling outward in convex arcs from hinges secured on the facing edges of the vertically separated canvases; and as apparent prints, left and right, made by these letters. That the "prints" are stenciled whereas their "originals" are not, that the sculptured letters may or may not leave traces of the same colors with which they are coated front and back—these multiply the conceptual discords of the field. But Johns knows that breakdown becomes best evident through the implication or presence of sequence. It is fascinating to see, in the logical carnage of *Field Painting*, the use of a device to impose order as simple and obvious as mirror imagery. What happens with one set of letters occurs also with the other, across the divide, and in reverse. Such as always in Johns's art, is the chief means for keeping us from thinking of too many things at once.

A real mirror occurs only once in his work in *Souvenir* (and its related versions), where it is placed so that it reflects nothing but a flashlight. The mirror association is made elsewhere on the canvas with a plate upon which is printed a

passport-type photograph of the artist. This is the only instance in Johns's career where he shows us his face. To gaze into a mirror is to see someone else, another person (who is one's self), "going" the wrong way. In *Studies for Skin*, there is accentuated that other illusion of a flat mirror, the sense it gives of an image behind its window-like plane irrevocably sealed off from our own space. There can be no doubt that Johns is personally obsessed by doubling and that it can represent for him, in the most poignant fashion, the spectacle of his own divided self. A plate bereft of food, or rather supplied with the artist's visage, a mirror giving back only light, a charcoal rubbing from his head that seems to have taken off its skin, all these intimate the savage cost of self-reflection. It is as if there are two artists involved, twins like the Corsican brothers, whose flesh can twinge with the experience of the other.

But it is more often the case that this twinship is visited upon neutral subjects, the better to show the true sibling relationship between perceiving things and remembering them. In this respect, a quote from Duchamp (from the *Green Box*), which Johns pointed out to Richard Field, is provocative:

<div align="center">

identifying

To lose the possibility of recognizing

2 similar objects—

2 colors, 2 laces

2 hats, 2 forms whatsoever

to reach the Impossibility of

visual

sufficient memory

to transfer

from one

like object to another

the *memory* imprint

————Same possibility

with sounds; with brain facts[14]

</div>

Field himself was then writing a book on Johns's prints, and the point of the exchange is perhaps highlighted by the

fact that a print is one of the two signal instances (the other being cast sculpture), of actual mirror imagery in visual art. For the printmaker must execute his subject in reverse to what will be seen by the spectator. *Study for Skin I* is itself a monoprint masquerading as a drawing. And it is remarkable, too, how frequent are Johns's applications of piecemeal printing techniques to painting. The handprints in *Periscope* (*Hart Crane*) and *Diver*, the iron print in *Passage I*, the serigraph newsprint in *According to What*, the wire-screen imprint in *Arrive/Depart*, and, of course, the stenciling everywhere, are typical examples. His art is rife with transfers "from one like object to another/the *memory* imprint . . ."[15] And in Johns's actual graphics, this understanding is fulfilled as much by their theme of testament to his past art as by the necessary transfers of their execution.

The same process characterizes his approach to sculpture too, for it can be no accident that his three-dimensional work is a reverie on the memory imprint produced by the embrace of "negative" mold and "positive" raw material. Volumes in sculpture, the artist seems to be saying, can be no more nor less than what has already been hollowed out through a literal casting from life. To be precise, the sculptor's hand moves from positive (the object), to negative (the mold), to positive again (the object sculpture), to issue, finally, a petrified alter ego of the "thing" out there. But it is, of course, no more a reproduction than the lips that originally modeled for *The Critic Sees* were inanimate. A transformation has occurred, had inevitably to occur, in which the perceived (that which is present) and the remembered (that which is absent) reciprocally expose their likenesses and differences, as would a mirror. Johns has even produced a death mask of a light bulb. We can perhaps go even further in isolating the fact that for this artist the act of creating proceeds inversely to the experience of responding to his art: Just as there must be a conception that leads him "forward" to certain fabrications, so, too, the spectator is obliged to shift his attention "backward" from the artwork in order to reconstruct its idea. Of course, such a practice is hardly exclusive with Jasper Johns. But it becomes self-conscious and poetic—and this is one of his greatest achievements—through structural emphasis.

When this structure is transposed on a two-dimensional plane—that is, when both resembling units are present in part, if not in whole—we re-encounter the trait that rather forcibly struck his early viewers: a tendency toward symmetry. For any plane figure that can be bisected by a line "is symmetric in the sense that it can be superposed, point for point, on its mirror image."[16] This can be tested by placing "the edge of a mirror on . . . [the figure] so that the exposed part of the figure, together with its reflection, form the original figure."[17] How many mirror comparisons are implied in

Johns: hidden along the central vertical axis in *Slow Field*, off to the right perimeter of the semicircle in *Periscope*, or invisible, between the two "Y's" of the forward and backward word "yellow," in the same work. That such possibilities emerge in the most unexpected places can make certain pictorial passages appear simultaneously right- and left-handed, potentially vertical to the gaze as well as horizontal, verso and recto (the two large words "RED" in *Land's End*), right-side up even when upside down. Expressed differently, this is to say that slides of selected Johns paintings can be shown in many of these ways and yet some of the writing in them will still read correctly. Whole areas of a picture may disorient viewing because they are indifferent to the advantages of right- or left-handedness or equilibrium. Even more than in the lettering, we can see in the circle (e.g., his targets), the ultimate example of this leaning, since circles are divisible by infinite axes of symmetry.

By now, it is clear that system choices of this sort do not function merely as a gross division of planar space or as a means to subvert invented relationships. Often, indeed, the relatedness of Johns's images have a formal consequence that is devastating, as when we are obliged to imagine the flat plane to bulk out like a drum or fold or become transparent. But the psychic import of these phenomena has an even greater claim on our attention. For not only are his symmetries rarely complete on the surface—being split or interrupted in their visual sequence—but they are so posed as to be continually incomplete in the mind. There is extended to us the possibility of matching general consciousness and artistic form on this abstract level. We would yet never be aware of this possibility were it not for the misleading resemblances cultivated by Johns. It is important that they be misleading, illusory—for that is the pass to which his literalism has come. If we have to be convinced of the irretrievability of our perceptions, Johns convinces us by holding a mirror up to them. Still, he is no absolutist. Memory, it is true, can never summon back its stimuli in the original form that they were received; but by materializing the blind spot that interferes between recall and perception, the artist shows how productive work is really carried on. Very probably this is to misconstrue Johns as something of a didactic artist. With him, every move taken is a lesson learned. But it is a move accompanied by a sense of loss. There can be no great joy in having to proceed through a dividedness which entails the persistent need to *regain* balance and *allude* to wholeness. And this is what finally gives to his art its clear-sighted enigmas, its lovely anguish.

Plates

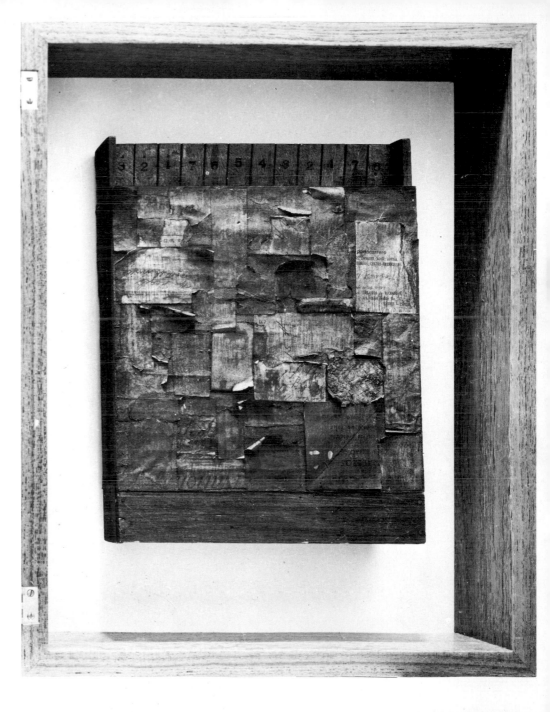

1. *Construction with Toy Piano.*
1954. Graphite and collage
with toy piano, 11 × 9 × 2″.
Collection Mr. and Mrs.
Robert C. Scull, New York

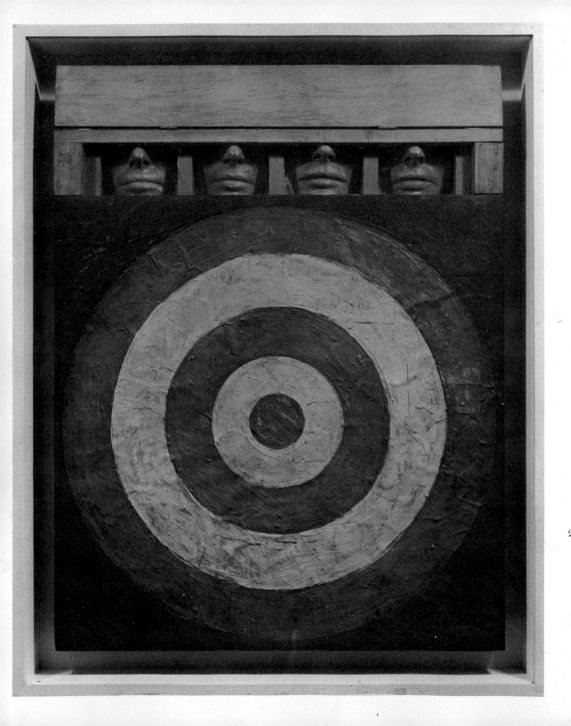

2. *Target with Four Faces*. 1955. Encaustic and collage on canvas with plaster casts, 29 3/4 × 26 × 3 3/4″. The Museum of Modern Art, New York. Gift of Mr. and Mrs. Robert C. Scull

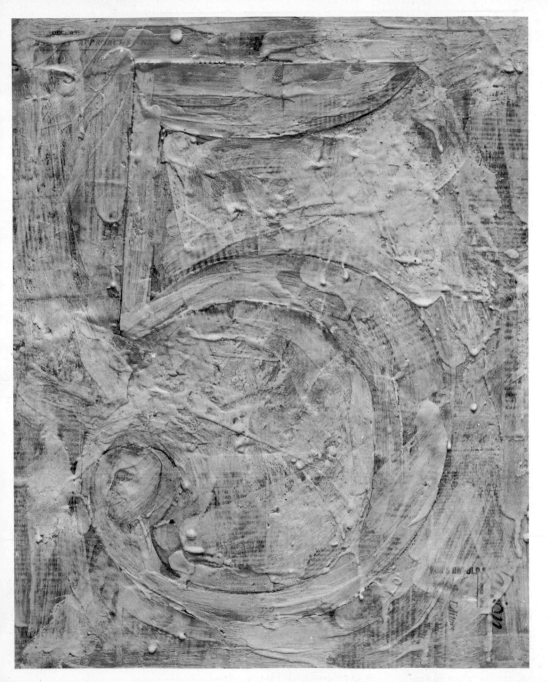

3. *Figure 5.* 1955.
 Encaustic and collage on canvas,
 17 1/2 × 14".
 Collection the artist

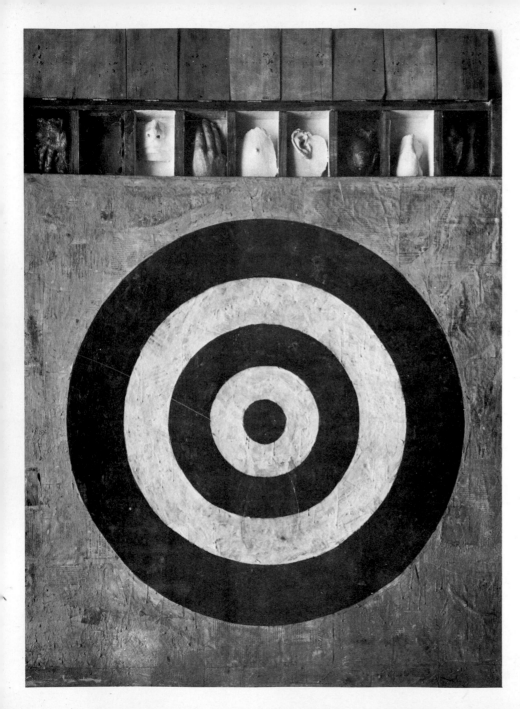

4. *Target with Plaster Casts.* 1955.
Encaustic and collage on canvas
with plaster casts, 51 × 44 × 3 1/2".
Collection Mr. and Mrs. Leo Castelli,
New York

5. *Canvas.* 1956.
Encaustic and collage on woo[d]
and canvas, 30 × 25".
Collection the artist

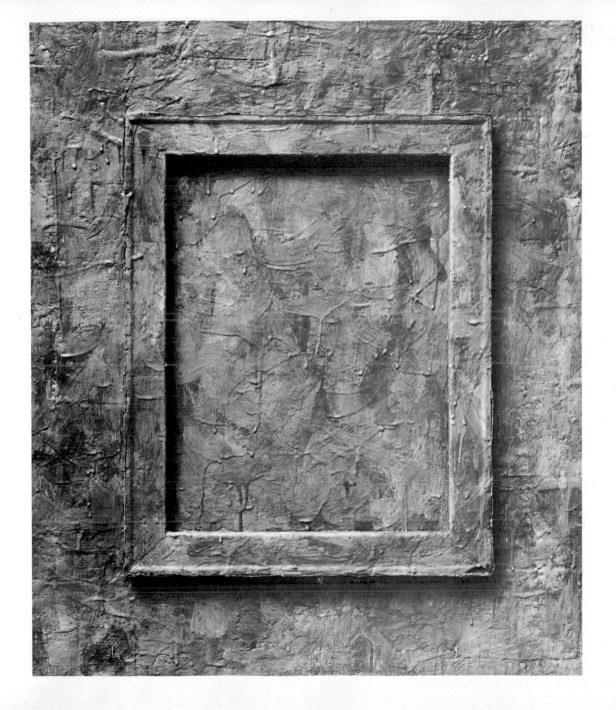

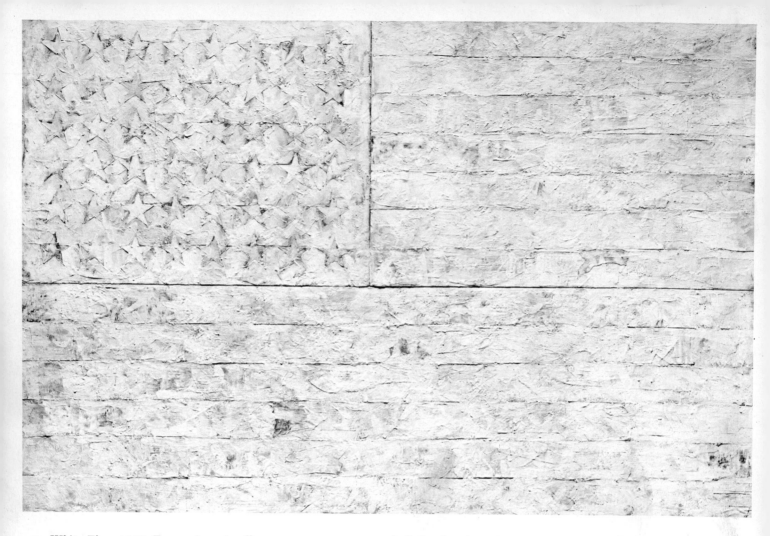

6. *White Flag*. 1955. Encaustic and collage on canvas, 72 × 144″. Collection the artist

7. *Flag Above White with Collage*. 1955. Encaustic and collage on canvas, 22 1/2 × 19 1/4″. Collection the artist

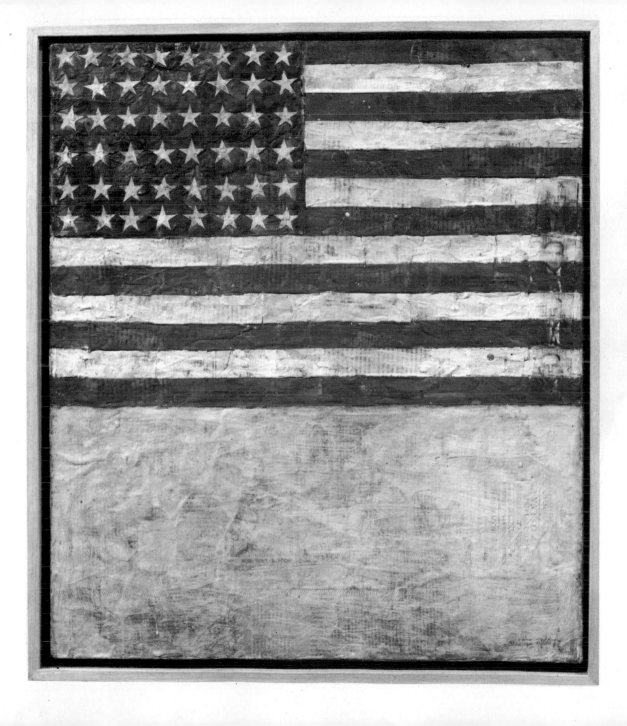

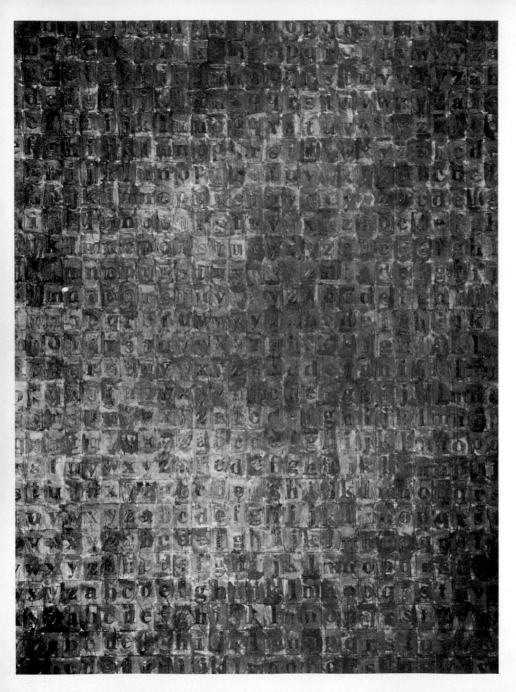

8. *Gray Alphabets*. 1956.
Encaustic and collage on canvas,
66 × 49″. Private collection

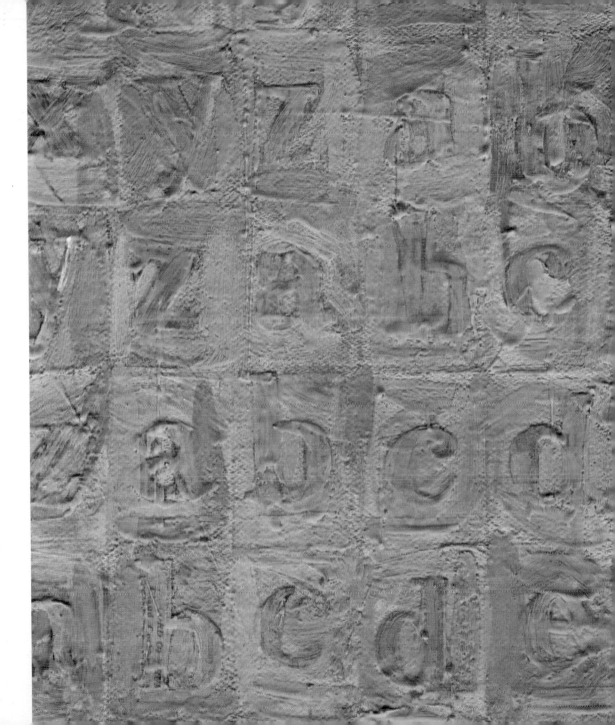

9. *Gray Alphabets*
detail of painting, plate 8)

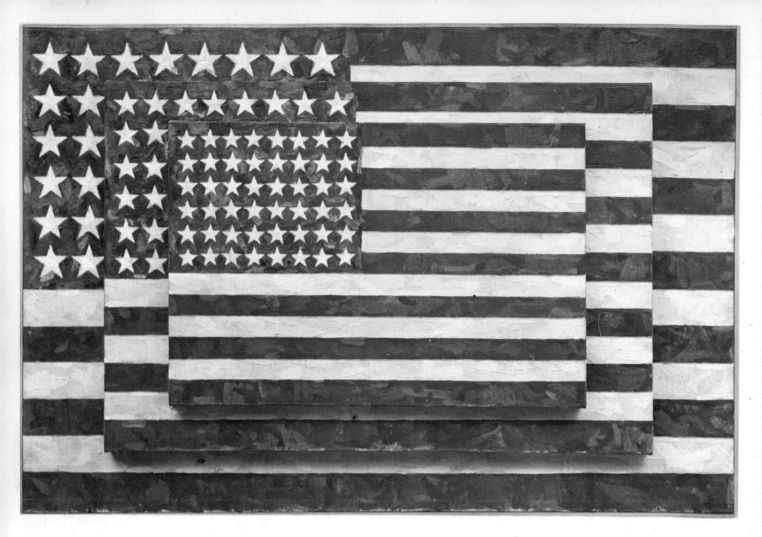

10. *Three Flags*. 1958. Encaustic on canvas (three levels), 30 7/8 × 45 1/2 × 5″.
Collection Mr. and Mrs. Burton Tremaine, Meriden, Connecticut

11. *Gray Rectangles*. 1957. Encaustic on canvas, 60 × 60″.
Collection Mr. and Mrs. Victor W. Ganz, New York

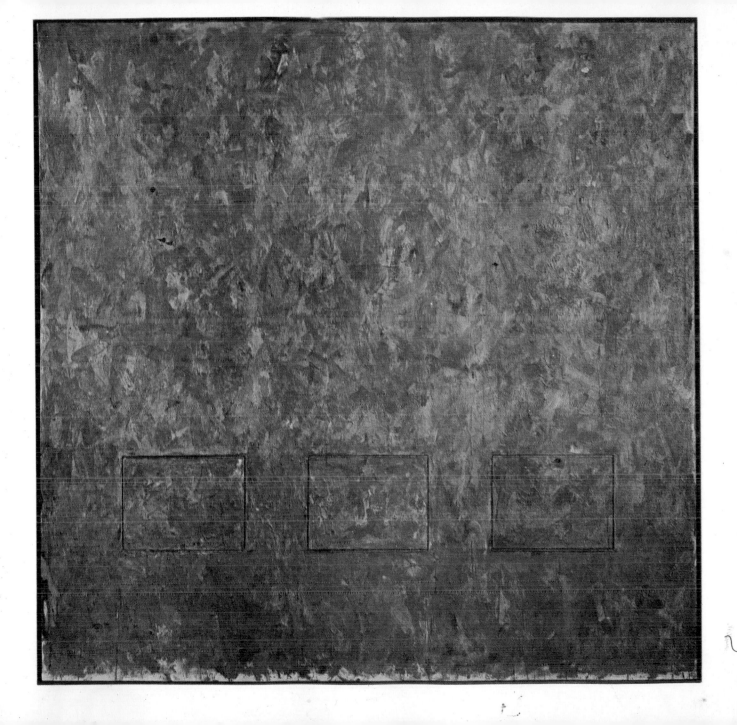

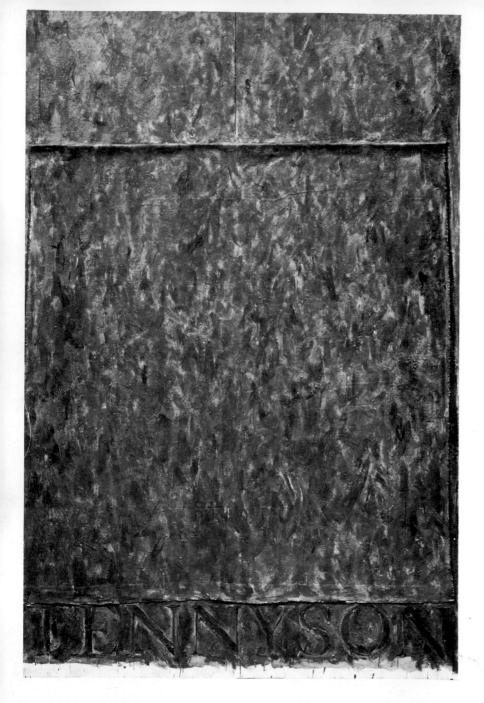

12. *Tennyson*. 1958.
Encaustic and canvas collage on canvas,
73 1/2 × 48 1/4". Collection Don Factor,
Beverly Hills, California

13. *Flashlight III*. 195
Plaster and glas
5 1/4 × 8 1/4 × 3 3/4
Collection the arti

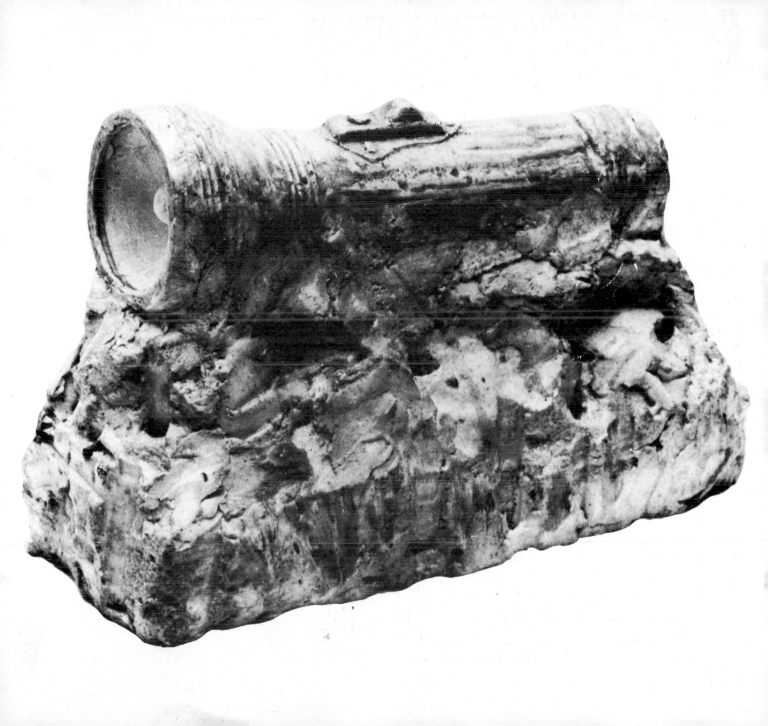

14. *Flag.* 1958. Pencil and graphite wash on paper, 7 1/2 × 10 3/8″. Collection Mr. and Mrs. Leo Castelli, New York

15. *Broken Target.* 1958. Conté crayon on paper, 15 1/2 × 15′
Collection Mr. and Mrs. Ben Heller, New Yor

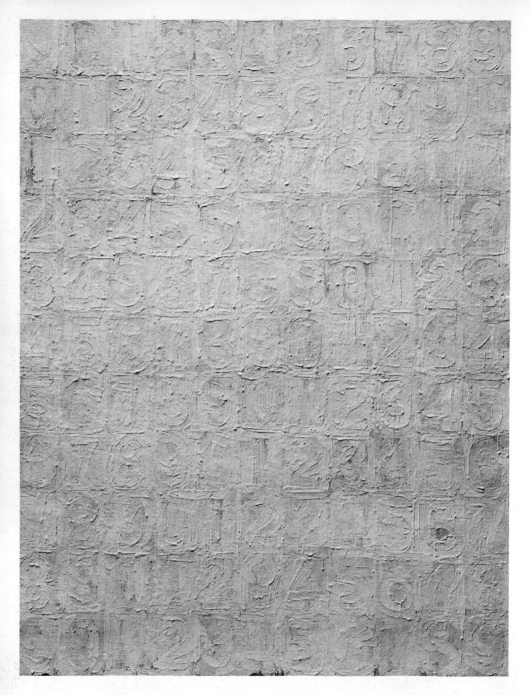

16. *White Numbers*. 1959.
Encaustic on canvas, 53 1/4 × 40″.
Collection Mr. and Mrs.
Victor W. Ganz, New York

17. *Coat Hanger*. 1959.
Encaustic on canvas with objects,
27 3/4 × 21 1/4″.
Collection Dr. and Mrs.
André Esselier, Zurich

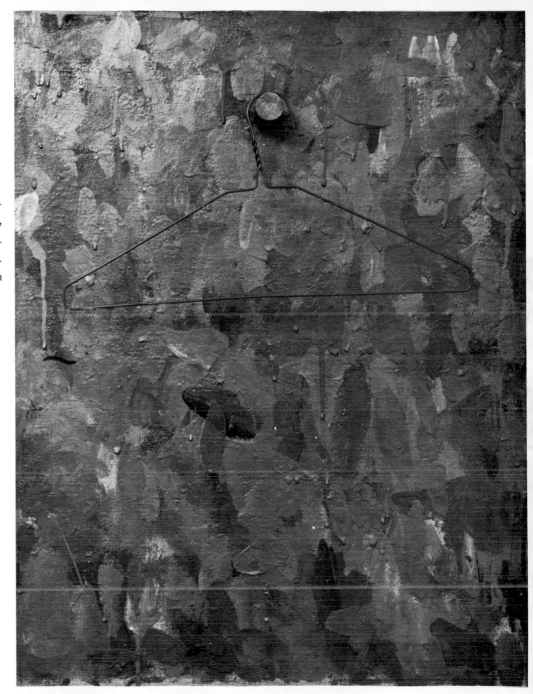

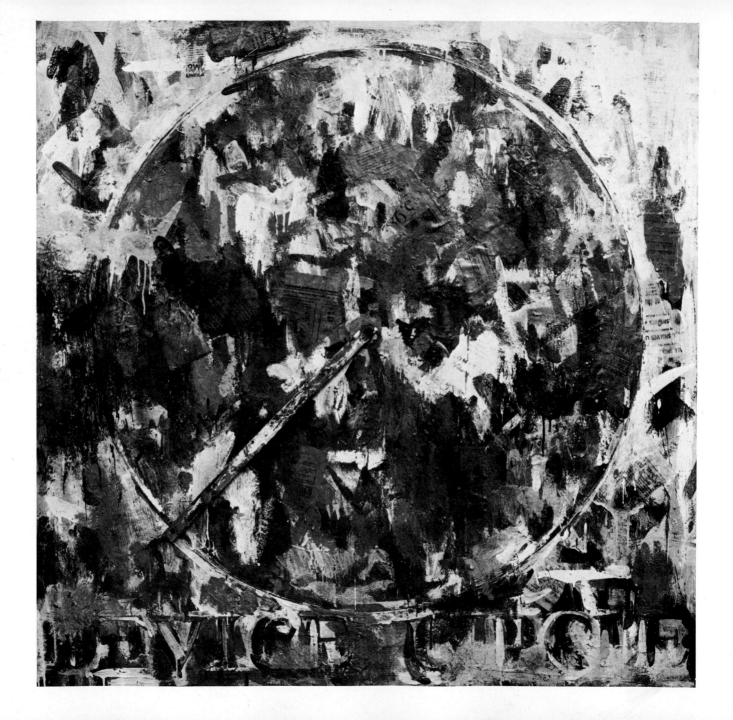

8. *Device Circle*. 1959.
Encaustic collage on canvas
with wood, 40 × 40″.
Collection Mr. and Mrs.
Burton Tremaine,
Meriden, Connecticut

19. *False Start*. 1959.
Oil on canvas, 67 1/4 × 54″.
Collection Mr. and Mrs.
Robert C. Scull, New York

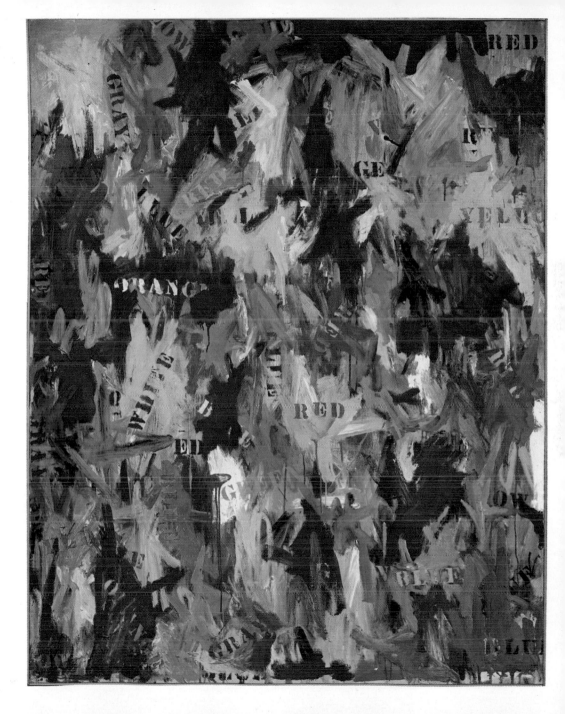

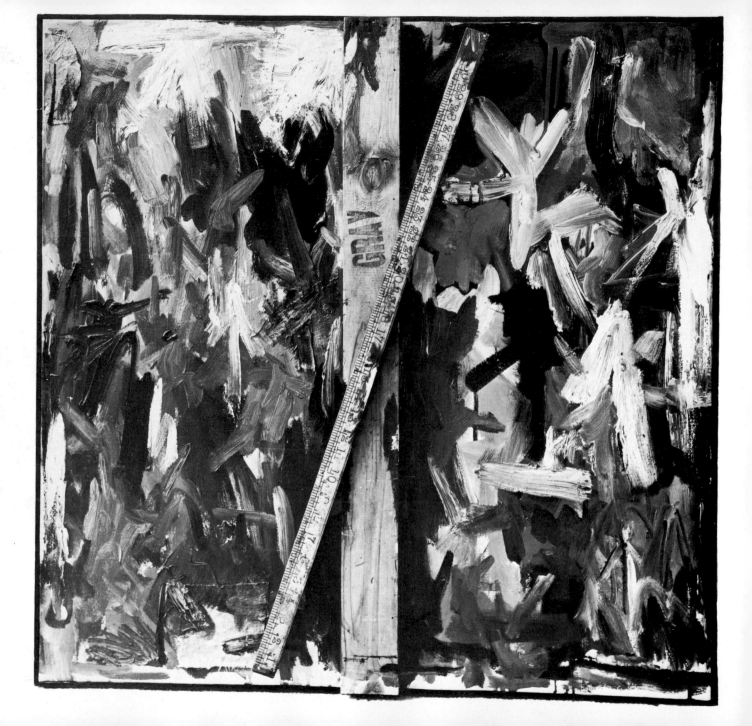

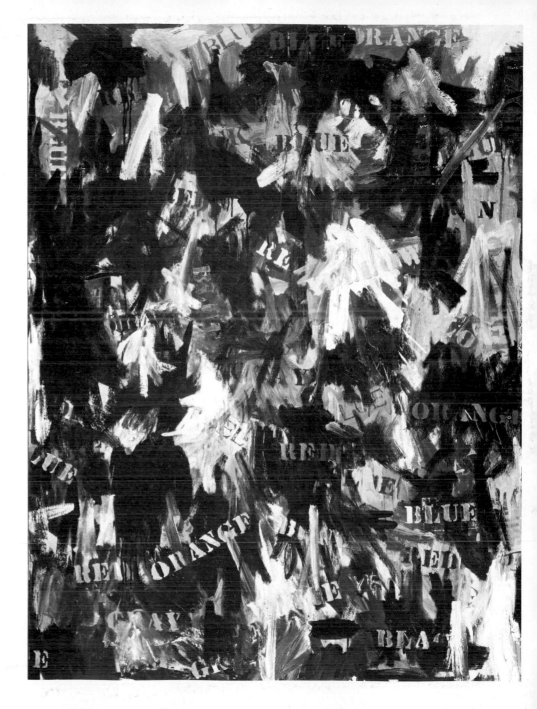

. *Painting with Ruler and "Gray."*
1960. Oil and collage on canvas
with objects, 32 × 32″.
Collection Mr. and Mrs.
Joseph Helman, St. Louis

21. *Jubilee.* 1959.
Oil on canvas, 67 1/4 × 54″.
Collection Robert Rauschenberg,
New York

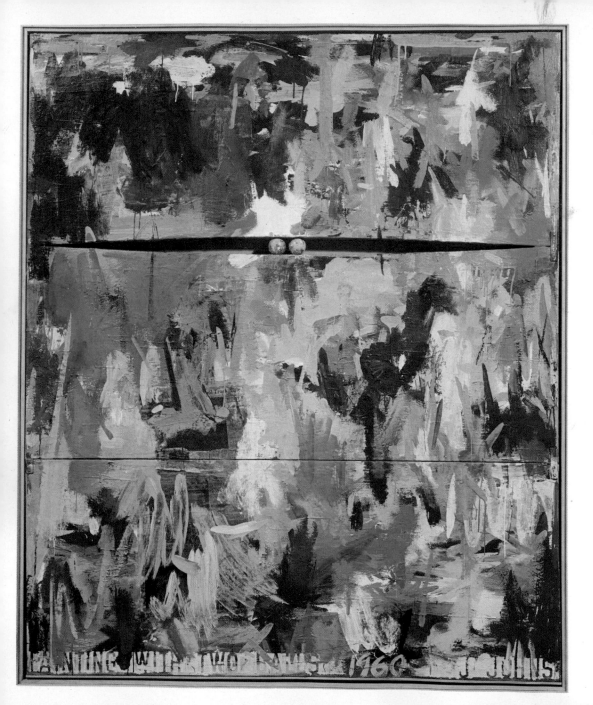

22. *Painting with Two Balls.*
Encaustic and collage on
canvas with objects, 65 ×
Collection the artist

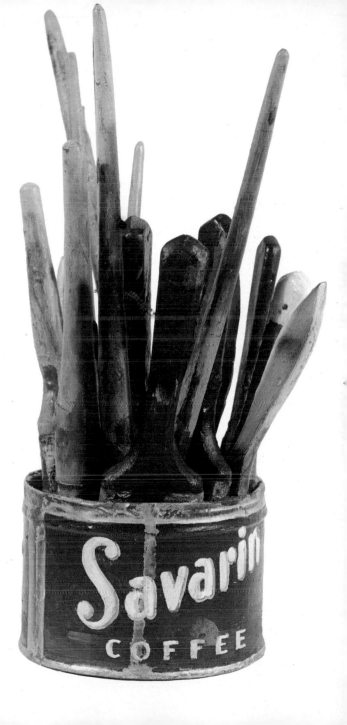

23. *Painted Bronze.* 1960. Painted bronze, height 13 1/2″,
diameter 8″. Collection the artist

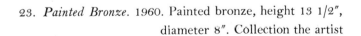

24. *Flag*. 1960. Sculpmetal and collage on canvas, 13 × 19 3/4". Collection Robert Rauschenberg, New York

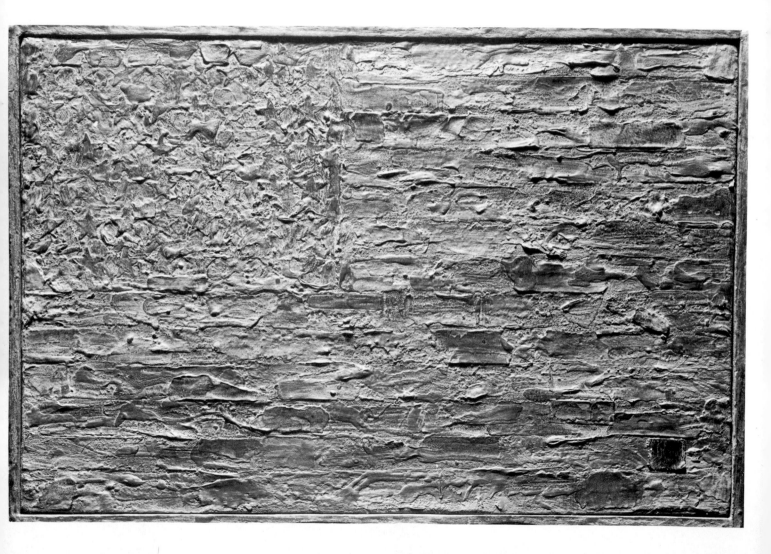

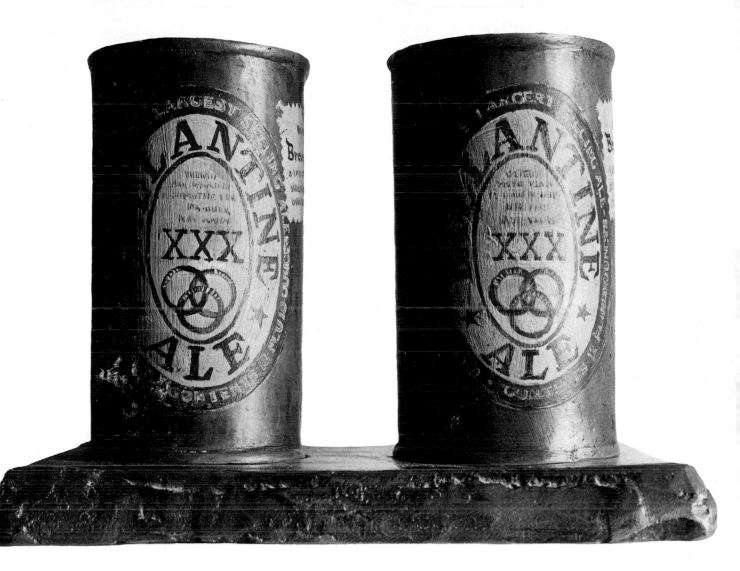

25. *Painted Bronze*. 1960. Painted bronze (2 casts), 5 1/2 × 8 × 4 3/4".
Collection Mr. and Mrs. Robert C. Scull, New York

Three Flags. 1960. Pencil on board
(3 levels), 11 1/4 × 16 1/2″.
Collection Ileana Sonnabend, Paris

27. *0 Through 9*. 1960.
Charcoal on paper, 29 × 23″.
Collection the artist

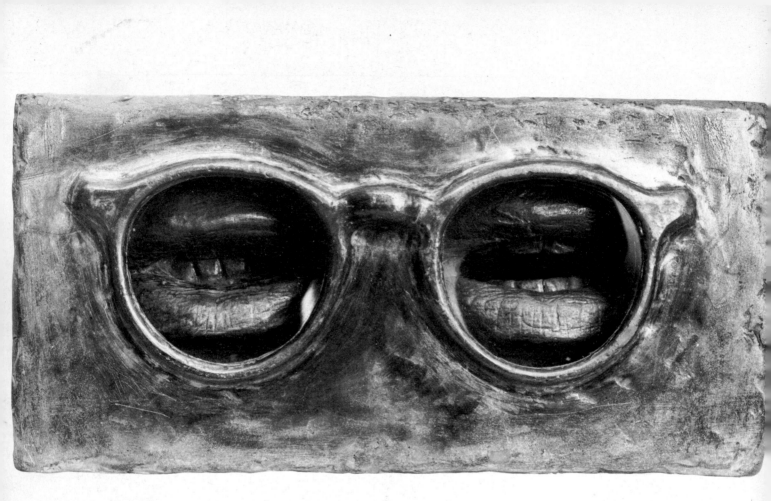

28. *The Critic Sees.* 1961. Sculpmetal on plaster with glass, 3 1/4 × 6 1/4 × 2 1/8″.
Collection Mr. and Mrs. Robert C. Scull, New York

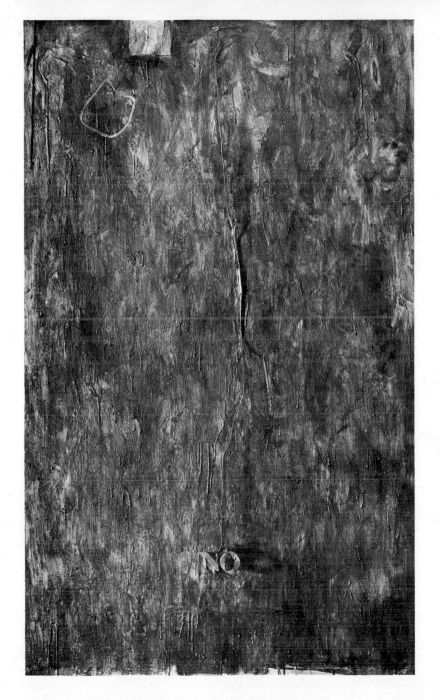

29. *No.* 1961. Encaustic, collage, and
Sculpmetal on canvas with objects,
68 × 40″. Collection the artist

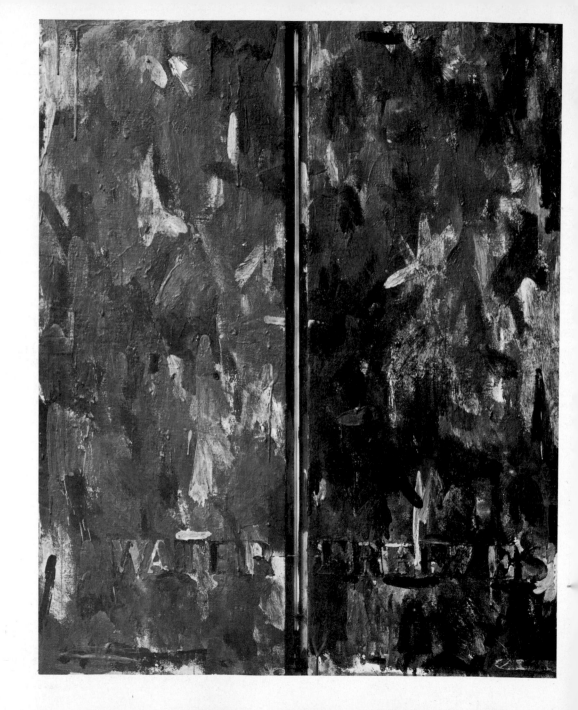

30. *Water Freezes*. 1961.
Encaustic on canvas with object, 31 × 25 1/4″.
Collection Mr. and Mrs. Gunnar Höglund,
Stockholm

31. *Good Time Charley*. 1961.
Encaustic on canvas with objects,
38 × 24″. Collection the artist

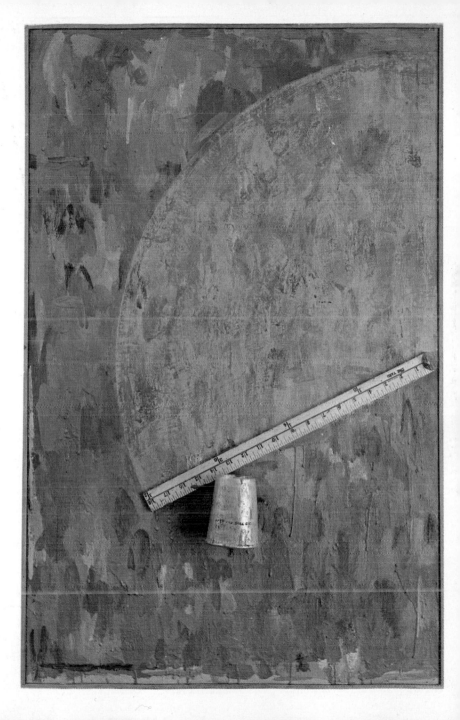

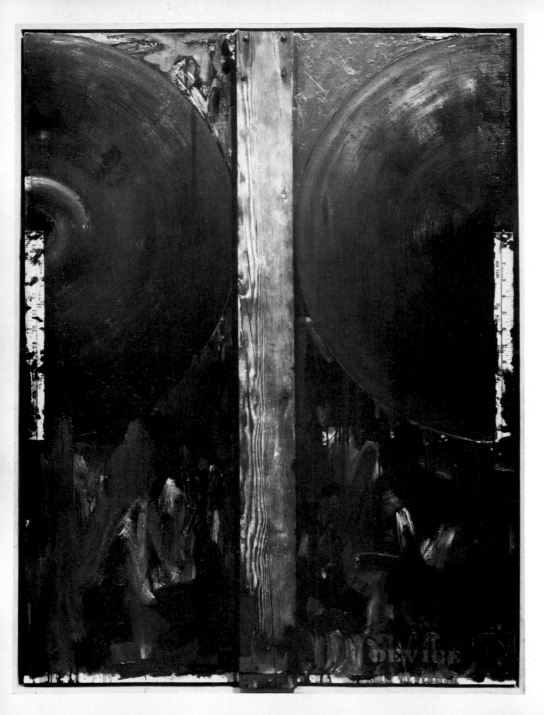

32. *Device*. 1962.
 Oil on canvas with wood, 40 × 30"
 Collection Ileana Sonnabend, Paris

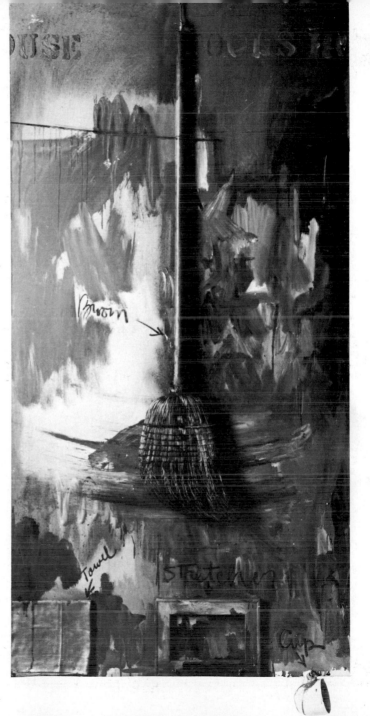

33. *Fool's House*. 1962. Oil on canvas with objects, 72 × 36".
Collection Jean Christophe Castelli, New York

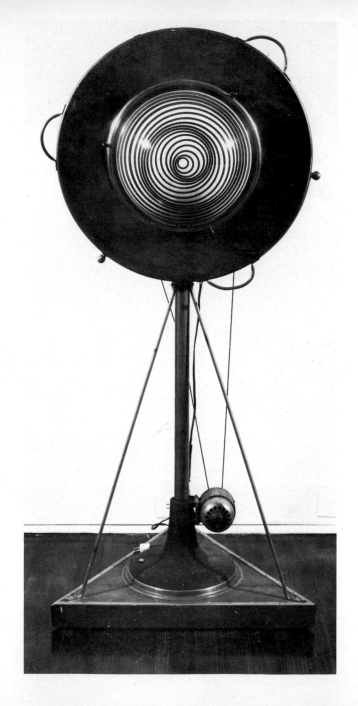

34. Marcel Duchamp. *Rotative Demisphere*
 (Optique de Précision). 1925.
 Copper disk with metal stand and electric motor,
 59 × 27 1/2 × 19 3/4".
 Collection Mrs. William Sisler, New York

35. *Disappearance II*. 1961.
Encaustic and canvas collage on canvas, 40 × 40".
Collection Mr. and Mrs. William Janss,
Thermal, California

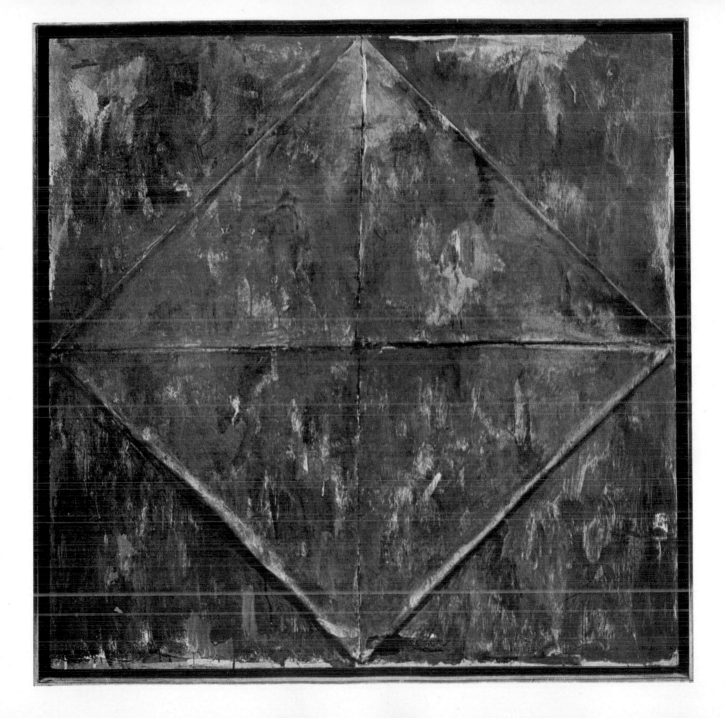

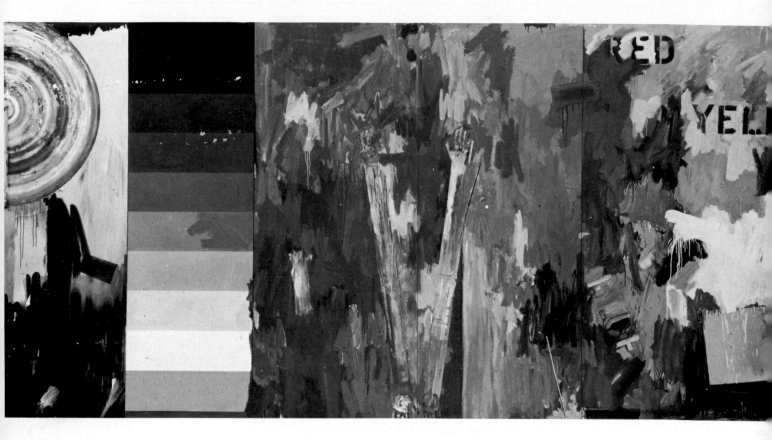

36. *Diver*. 1962. Oil on canvas with objects, 7′6″ × 14′2″. Albert A. List Family Collection

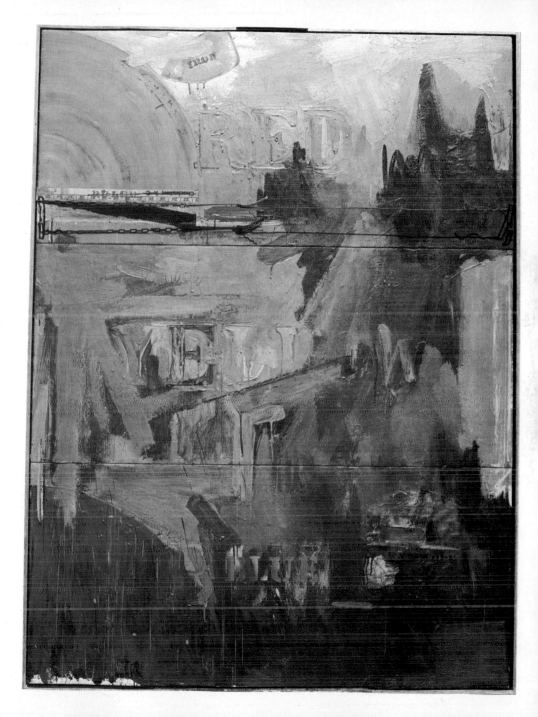

37. *Passage*. 1962.
Encaustic and collage on canvas
with objects, 54 × 40".
Private collection

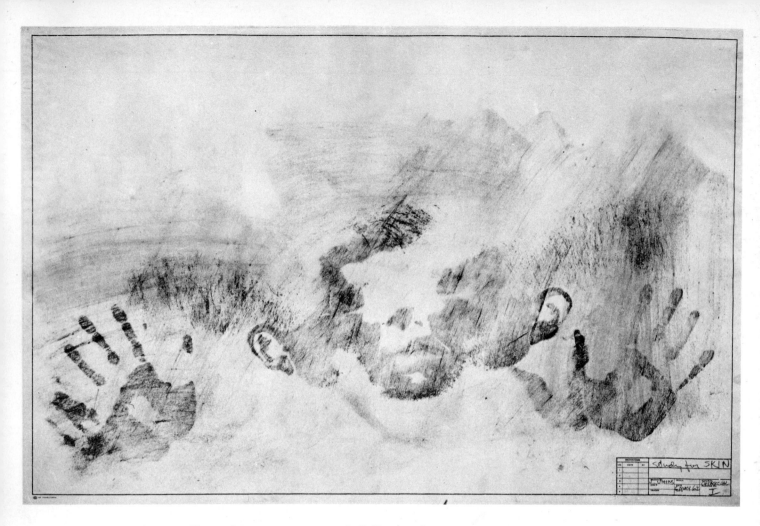

38. *Study for Skin I*. 1962. Charcoal on paper, 22 × 34″. Collection the artist

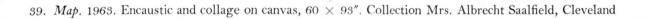

39. *Map*. 1963. Encaustic and collage on canvas, 60 × 93″. Collection Mrs. Albrecht Saalfield, Cleveland

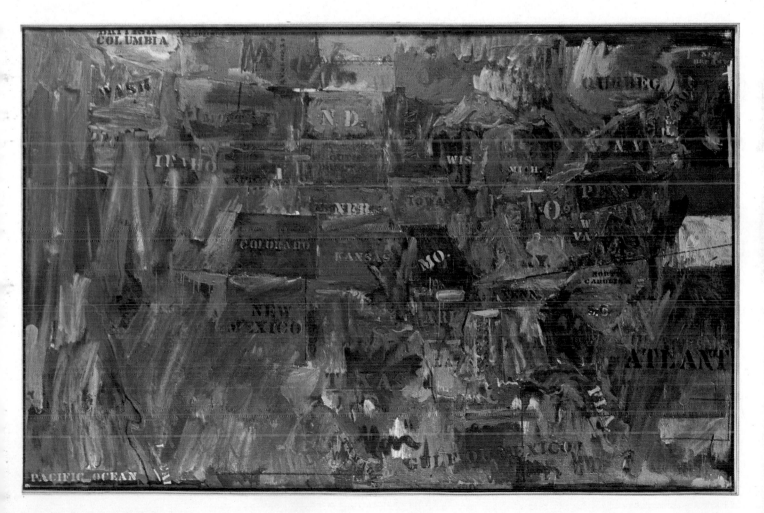

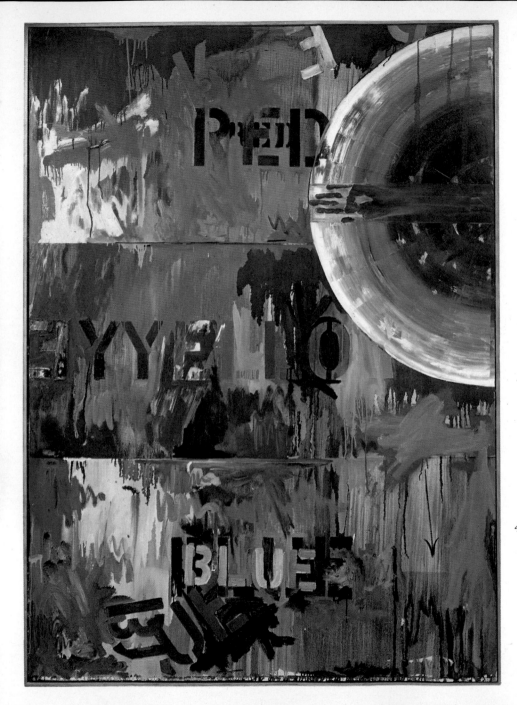

40. *Periscope (Hart Crane)*.
1963. Oil on canvas, 67 × 48″
Collection the artist

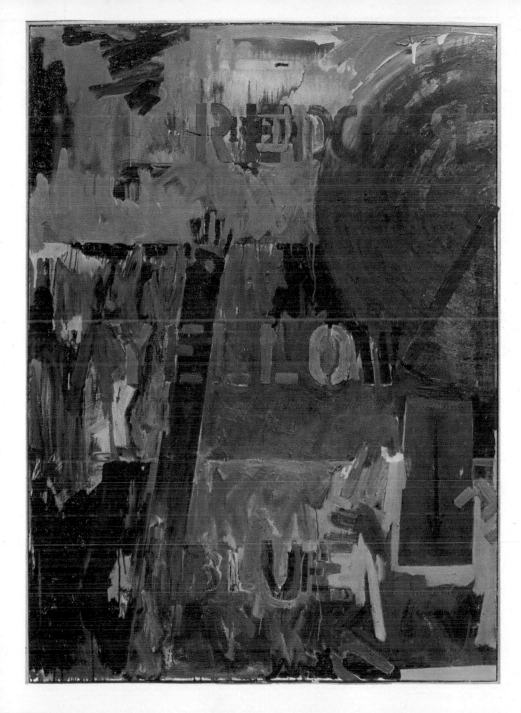

41. *Land's End.* 1963.
Oil on canvas with wood, 67 × 48″.
Collection Edwin Janss Jr.,
Los Angeles

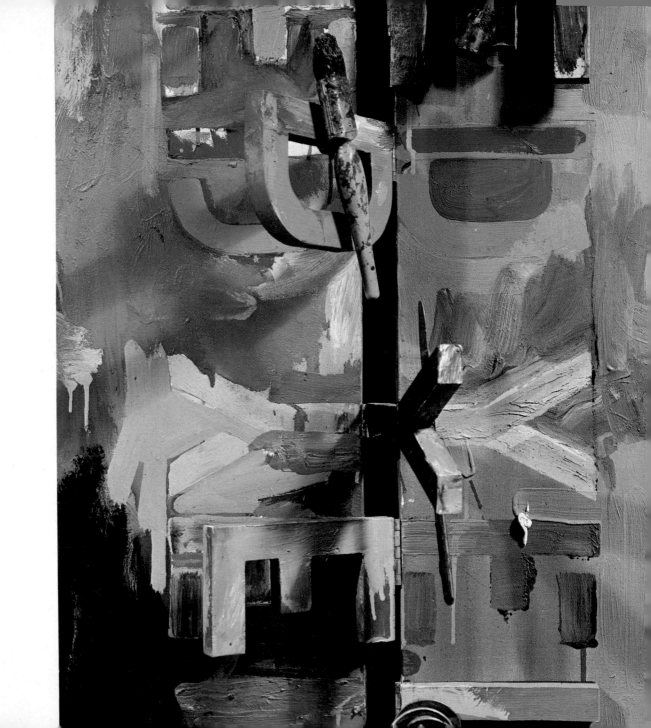

2. *Field Painting* (detail of painting, plate 43)

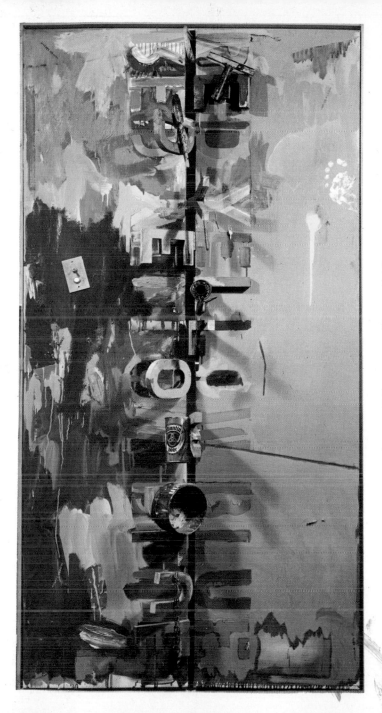

43. *Field Painting*. 1963–64. Oil on canvas with objects,
72 × 36 3/4″. Collection the artist

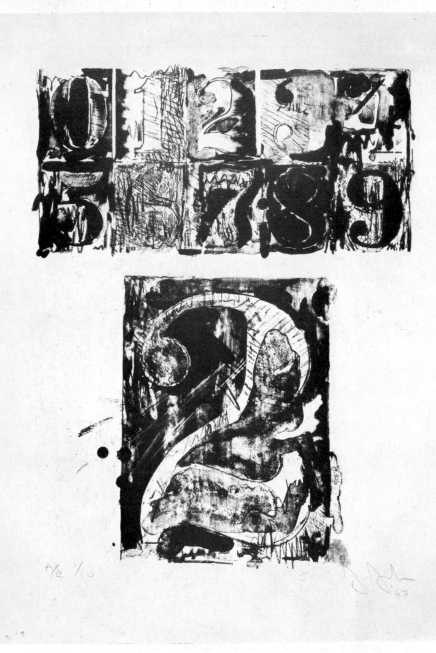

44. *0–9.* 1963. Lithograph,
20 1/2 × 15 1/2″. Published by
Universal Limited Art Editions,
West Islip, New York

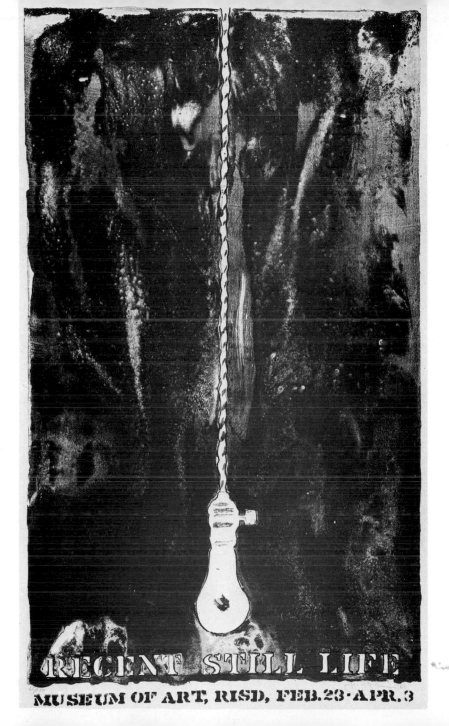

45. *Light Bulb* (poster for an exhibition
at the Rhode Island School of Design). 1963.
Lithograph, 35 × 20″.
Published by Universal Limited Art Editions,
West Islip, New York

46. *Arrive/Depart*. 1963–64.
Oil on canvas, 68 × 51 1/2″.
Collection Klaus Gebhard, Munich

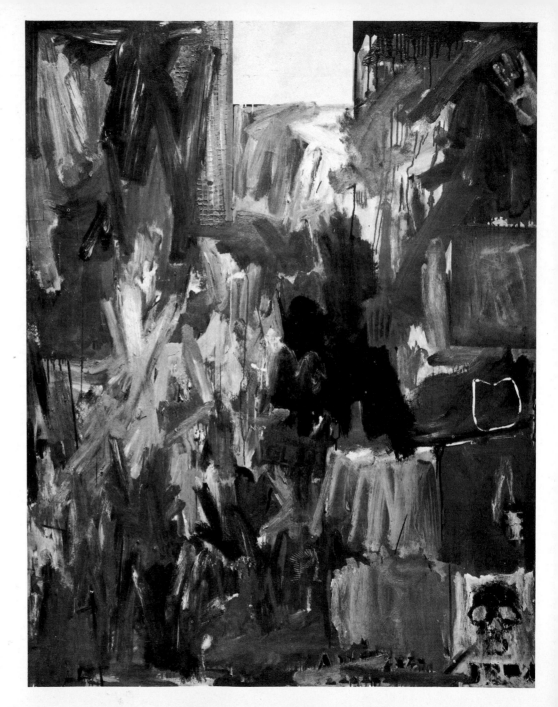

47. *Souvenir.* 1964.
Encaustic on canvas with objects,
28 3/4 × 21".
Minami Gallery, Tokyo

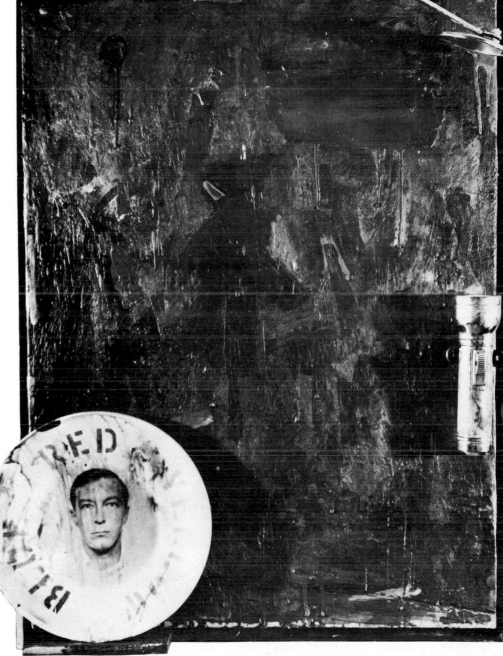

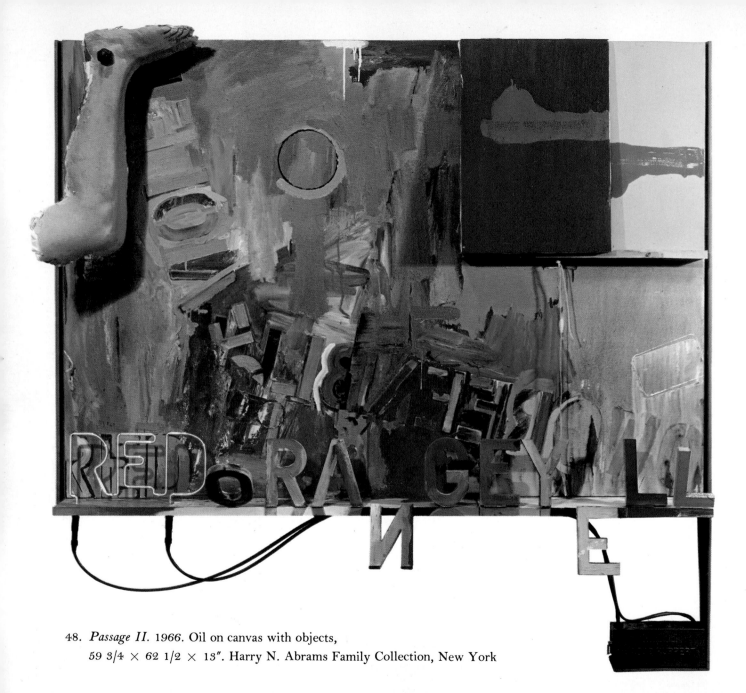

48. *Passage II*. 1966. Oil on canvas with objects,
59 3/4 × 62 1/2 × 13″. Harry N. Abrams Family Collection, New York

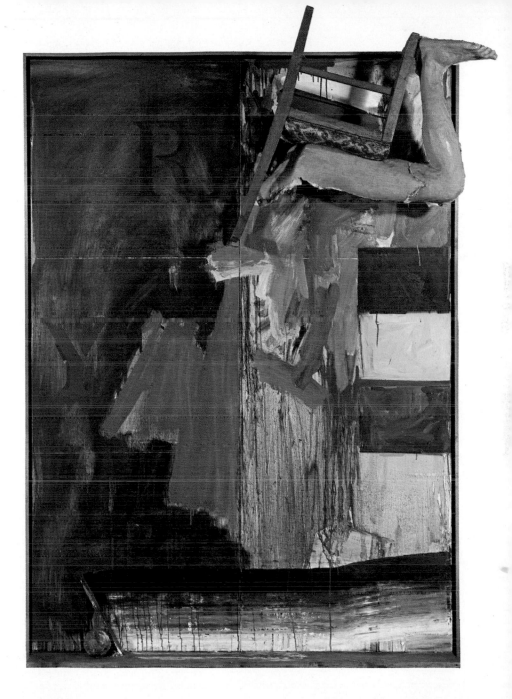

49. *Watchman*. 1964.
Oil on canvas with objects, 85 × 60 1/4".
Collection Sōfū Teshigahara, Tokyo

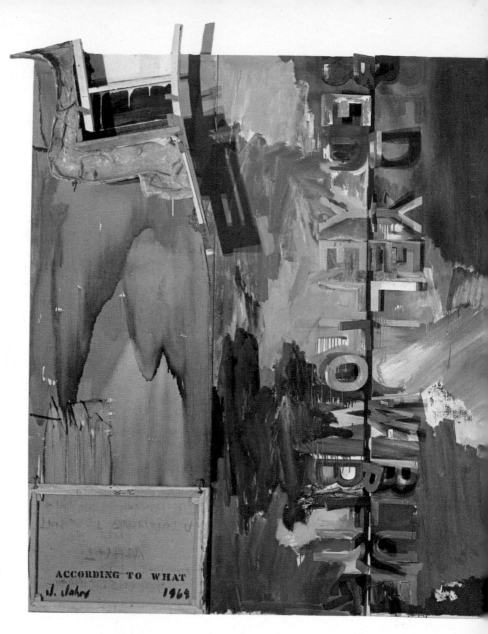

50. *According to What*. 1964.
Oil on canvas with objects, 88 × 192″.
Collection Edwin Janss Jr., Los Angeles

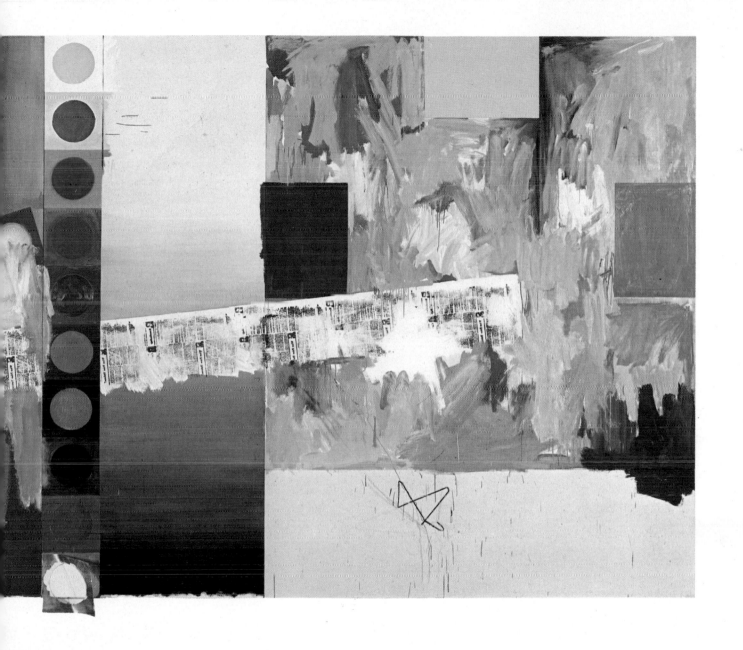

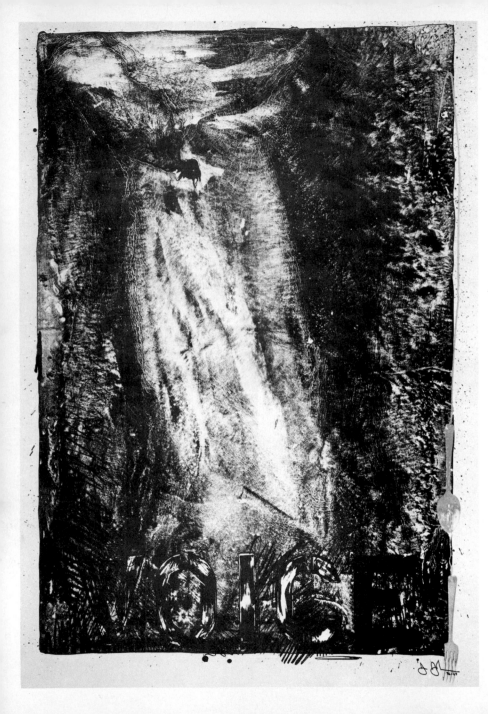

51. *Voice*. 1967.
 Lithograph, 48 1/2 × 32″.
 Published by Universal Limited
 Art Editions, West Islip,
 New York

Notes

1. Joseph Heller, *Catch–22*, New York, 1970, p. 47.

2. Morton Feldman, "Give my regards to Eighth Street," *Art in America*, March–April, 1971, p. 99.

3. Ludwig Wittgenstein, *Tractatus Logico-Philosophicus*, London, 1961, pp. 149–51.

4. Quoted by James Johnson Sweeney in Robert Lebel, *Marcel Duchamp*, New York, 1959, p. 85.

5. Robert Morris, "Notes on Sculpture, Part IV: Beyond Objects," *Artforum*, April, 1969, p. 50.

6. Quoted by William S. Rubin, *Frank Stella*, The Museum of Modern Art, New York, 1970, p. 12.

7. Quoted in Maurice Tuchman, *A Report on the Art and Technology Program of the Los Angeles County Museum of Art*, 1967–71, p. 17.

8. Jasper Johns, "Sketchbook Notes," *Art and Literature*, Spring, 1965, p. 192.

9. Sigmund Freud, "A Note upon the 'Mystic Writing-Pad'," *The Complete Psychological Works of Sigmund Freud*, vol. 19, London, 1961, p. 230.

10. *Ibid.*, pp. 230–31.

11. *Ibid.*, p. 232.

12. Max Kozloff, *Jasper Johns*, New York, 1969.

13. Richard S. Field, *Jasper Johns: Prints 1960–1970*, Philadelphia Museum of Art, 1970 (unpaginated).

14. Quoted by Richard S. Field, *op. cit.*, from Richard Hamilton, *The Bride Stripped Bare by Her Bachelors, Even: A Typographical Version of Marcel Duchamp's Green Box*, translated by George Heard Hamilton, London, 1960.

15. *Ibid.*

16. Martin Gardner, *The Ambidextrous Universe*, New York, 1964, pp. 11–12.

17. *Ibid.*, p. 13.

Selected Bibliography

Alloway, Lawrence. Untitled essay in *Six Painters and the Object*, catalogue of the exhibition at the Guggenheim Museum, New York, 1963.

Ashbery, John. "Brooms and Prisms," *Art News*, vol. 65, no. 1 (March, 1965).

Cage, John. "Jasper Johns: Stories and Ideas," in *Jasper Johns*, catalogue of the exhibition at the Jewish Museum, New York, 1964.

Factor, Donald. "Jasper Johns," *Artforum*, vol. 3, no. 6 (March, 1965).

Field, Richard S. *Jasper Johns: Prints 1960–1970*, Philadelphia Museum of Art, 1970.

Forge, Andrew. "The Emperor's Flag," *The New Statesman* (December 11, 1964).

Fried, Michael. "New York Letter," *Art International*, vol. 7, no. 2 (February 25, 1963).

Greenberg, Clement. "After Abstract Expressionism," *Art International*, vol. 6, no. 8 (October 25, 1962).

Hopps, Walter. "An Interview with Jasper Johns," *Artforum*, vol. 3, no. 6 (March, 1965).

Janis, Harriet and Rudi Blesh. *Collage*, Chilton, Philadelphia, and New York, 1962.

Johns, Jasper. "Sketchbook Notes," *Art and Literature*, vol. 4 (Spring, 1965).

———. Recording of an interview accompanying *The Popular Image*, catalogue of the exhibition at the Washington Gallery of Modern Art, Washington, D.C., 1963.

Johnson, Ellen. "Jim Dine and Jasper Johns: Art about Art," *Art and Literature*, vol. 6 (1965).

Kozloff, Max. *Jasper Johns*, New York, 1969.

———. "Letter to the Editor," *Art International*, vol. 7, no. 6 (June 25, 1963).

———. "Art," *The Nation*, vol. 198, no. 12 (March 16, 1964).

———. "Johns and Duchamp," *Art International*, vol. 3, no. 2 (March 20, 1964).

———. "Painting," in *The New American Arts*, ed. Richard Kostelanetz, New York, 1965.

Krauss, Rosalind. "Jasper Johns," *The Lugano Review*, vol. 1/2, II (1965).

Lippard, Lucy. *Pop Art*, New York, 1966.

Porter, Fairfield. "The Education of Jasper Johns," *Art News*, vol. 62, no. 10 (February, 1964).

Restany, Pierre. "Jasper Johns and the Metaphysic of the Commonplace," *Cimaise*, vol. 8, no. 3 (September, 1961).

Rose, Barbara. "The Second Generation: Academy and Breakthrough," *Artforum*, vol. 4, no. 1 (September, 1965).

———. "Dada Then and Now," *Art International*, vol. 7, no. 1 (January 25, 1963).

Rosenberg, Harold. "Jasper Johns: Things the Mind Already Knows," *Vogue*, vol. 143, no. 3 (February, 1964).

Rosenblum, Robert. "Jasper Johns," *Art International*, vol. 4, no. 7 (September 9, 1960).

——— "Les Oeuvres récentes de Jasper Johns," *XXᵉ Siècle*, vol. 4, no. 24 sup. (February, 1962).

Sandler, Irving. "New York Letter," *Art International*, vol. 5, no. 4 (April 5, 1961).

Seitz, William C. *The Art of Assemblage*, New York, 1961.

Solomon, Alan R. "The New Art," in *The Popular Image*, catalogue of the exhibition at the Washington Gallery of Modern Art, Washington, D.C., 1963.

———. "Jasper Johns," in *Jasper Johns*, catalogue of the exhibition at the Jewish Museum, New York, 1964.

Steinberg, Leo. "Contemporary Art and the Plight of its Public," *Harper's Magazine*, vol. 224, no. 1342 (March, 1962).

———. *Jasper Johns*, New York, 1963.

Swenson, G. R. "What is Pop Art? Interview with Jasper Johns," *Art News*, vol. 62, no. 10 (February, 1964).

Sylvester, David. Unpublished transcript of interview with Jasper Johns at Edisto Beach, South Carolina, 1965.

———. "Art in a Coke Climate," *The Sunday Times Magazine* of *The London Times* (January 26, 1964).

Tillim, Sidney. "Ten Years of Jasper Johns," *Arts*, vol. 38, no. 7 (April, 1964).

———. "Month in Review," *Arts*, vol. 37, no. 6 (March, 1963).